MOMENT BY MOMENT

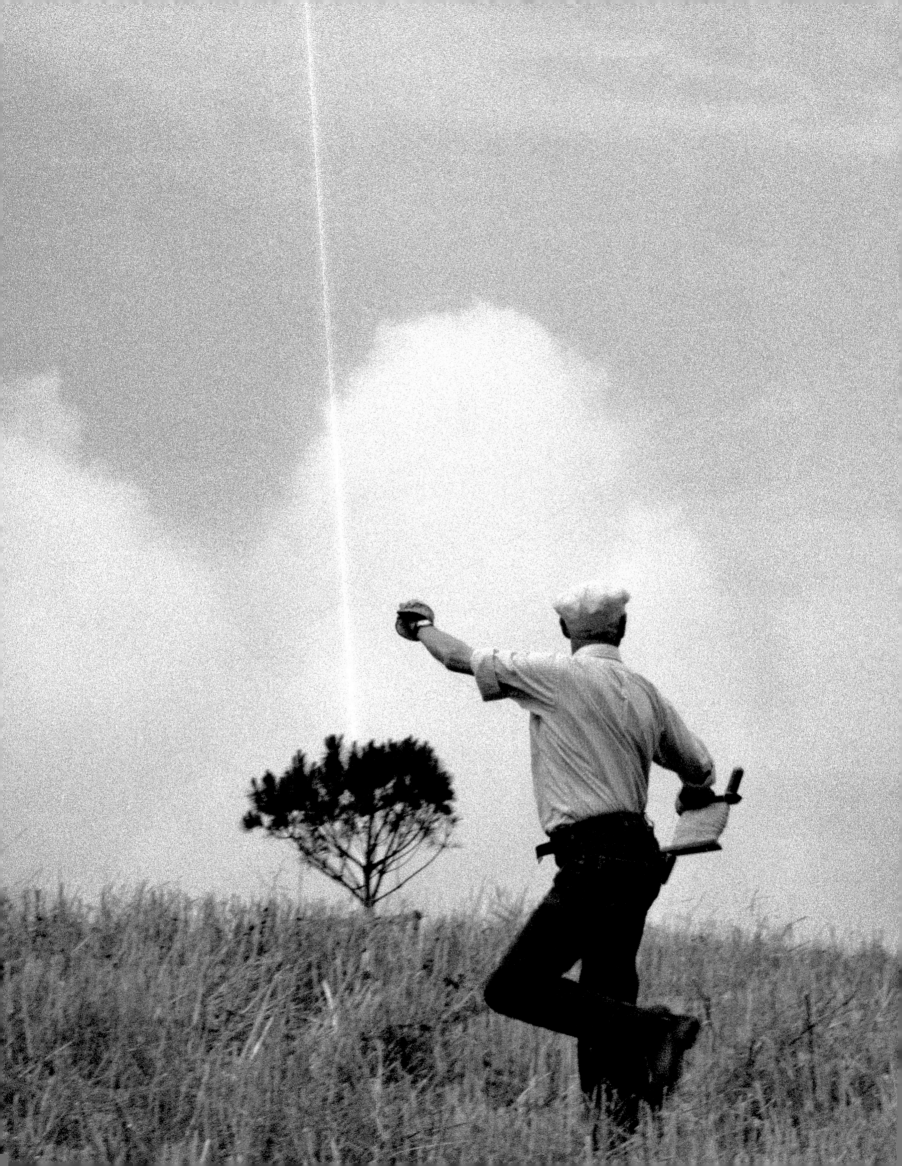

MOMENT
BY MOMENT

PHOTOGRAPHS BY
JOHN LOENGARD

Thames & Hudson

Author's Acknowledgments

I want to thank all my subjects for being there, in front of the camera. One of them, Jill Gill, also brought surprises to the pictures' pairings with her instinctively collagist eye. Robert Shnayerson's wise counsel shaped the book's concept. Philippe Laumont, with Tom Hurley and Shamus Clisset, helped bring the pictures into the digital world. Christopher Sweet's sure and sympathetic hand brought the book into being at Thames & Hudson. He recommended Laura Lindgren, the book's designer, which is a kindness to our eyes. My sweetest friend Maggie Simmons pulled precise advice from her editorial soul; it is always helpful and true.

Designed by Laura Lindgren

First published in the United States of America in 2016 by
Thames & Hudson Inc.
500 Fifth Avenue
New York, New York 10110

www.thamesandhudsonusa.com

Library of Congress Control Number: 2016932143

First published in the United Kingdom in 2016 by
Thames & Hudson Ltd
181A High Holborn
London WC1V 7QX

www.thamesandhudson.com

British Library Cataloguing-in-Publication Data
A catalogue record for this book is available from the British Library

ISBN 978-0-500-97077-5

Jacket front: The Beatles, 1964, Miami Beach, Florida (p. 83)
Jacket back: A Mancunian, 1968, Manchester, England (p. 13)
Case cover: Philip Pearlstein, 1966, New York City (pp. 74–75)
Pages 2–3: Henri Cartier-Bresson, 1987, near Forcalquier, Provence. Outside his summer home, photographer Henri Cartier-Bresson launches the kite he often flies with his daughter Mélanie.

Printed and bound in China by C&C Offset Printing Co . , Ltd.

For Duncan, Maia, and Jacqueline

PREFACE

"I confess that a fascination with impermanence—the world's torrential changes—has given me a respect for photography as an art of freezing instants that can never be exactly repeated. Nothing else (not painting) quite matches the veracity and longevity of an honest photograph."

— ROBERT SHNAYERSON

The light changes. The camera shifts. The subject moves. The wind blows. Who knows? The fact is: a good photograph cannot be repeated. That may explain why an image of a brief moment, an instant in time, can hold our interest forever.

As a magazine photographer, I've searched for telling moments, moving from one possibility to another. In 1965 when fans of Louis Armstrong thought the famous trumpet player might have "lost his lip" (his music might have lost its edge), there seemed no way to address that question in a photograph except, possibly, to photograph that lip. After a performance Mr. Armstrong put salve on it. The setting was a sixty-five-year-old man sitting at a dressing table in Las Vegas. He put the balm on his lip with a finger, and I recorded that close-up (page 90). On page 71, in contrast to that private moment, there is a moment of public scrutiny as Senator Edward Kennedy arrived in Plymouth, Pennsylvania, for the burial of Mary Jo Kopechne. (The public had not seen or heard anything from the senator in the four days since he reported to police his involvement in her fatal automobile accident on Chappaquiddick Island in Massachusetts.) And both pictures share a bond with a photograph of a fence in the Shaker community at Sabbathday Lake, Maine, on page 67. That picture caught no human action, and yet it is a

moment, an organized image that would be different if not seen at that instant, in that light, exactly from that point of view.

The moment aside, I felt I had run out of subjects when I was fifteen, four years after falling in love with the camera and what it could do. I'd taken pictures of my family and friends and all the neighborhood landmarks. Then an editor on my school newspaper asked me to photograph the captain of the football team. Walking out on the practice field and asking the big man to kick a ball, I found that with a newspaper in my hip pocket, so to speak, I might go anywhere with a purpose and be welcomed. The picture was in black-and-white and, when using film, I still take pictures mostly in black-and-white. Color photographs are more life-like, but ones in black-and-white are often more convincing.

Photographs should speak for themselves, but I'll make one exception. When I visit southern California, I sometimes have a feeling no one is really there. Californians live in autos, their landscapes quite different from the crowded sidewalks of my native Manhattan. At Long Beach, on pages 14–15, oil derricks were camouflaged to resemble high-rise buildings. They seemed to offer a way to put in a photograph the feelings I find difficult to put in words: southern California's subterranean tempo of emptiness and loneliness. The color of the sand or of the sky would take attention from the pair of men, the footprints of absent bathers and the oil derricks in their disguise.

That was the scene. The moment came when one man lifts his head to look toward the towers. The shutter opens briefly to let the camera marry reality to form. Their union gives the picture structure and defines the moment that lives on.

–John Loengard

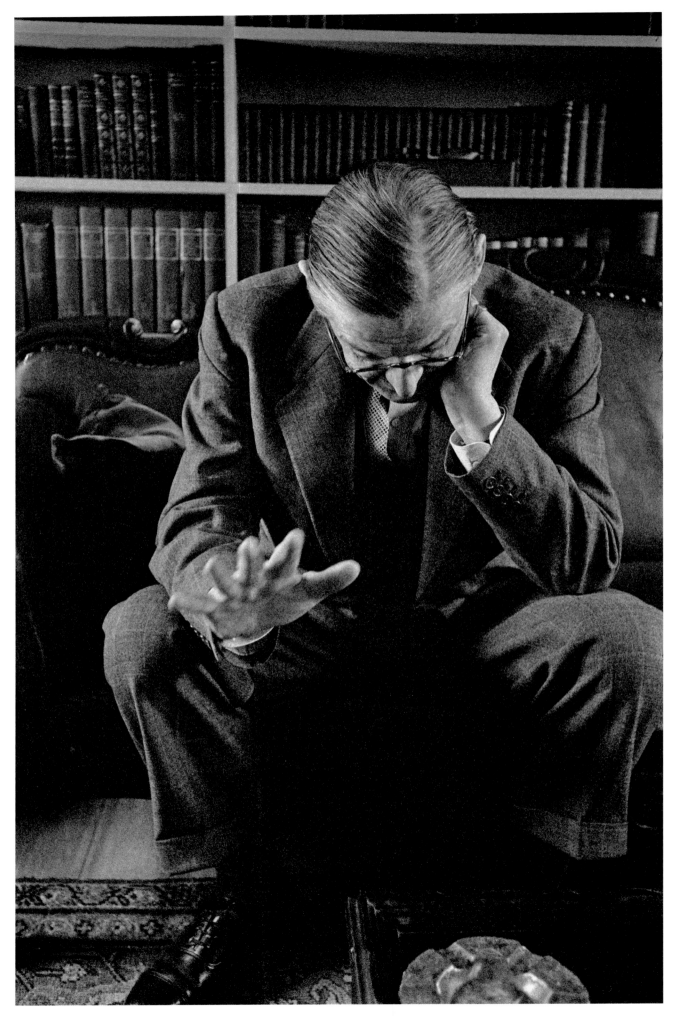

1956 Cambridge, Massachusetts
When the poet visits friends in Cambridge, he is interviewed by a reporter from *The Harvard Crimson*.

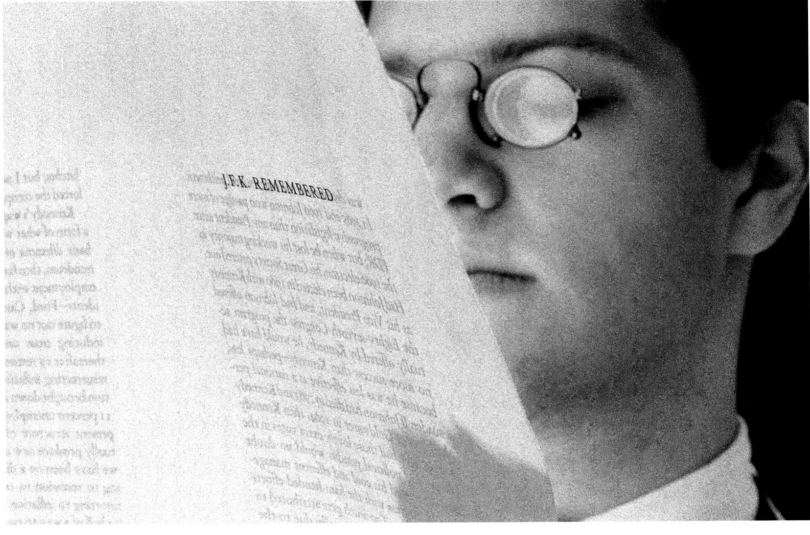

1988 West Stockbridge, Massachusetts
Harvard sophomore Luke Pontifell set the type for *JFK Remembered*, the 1983 essay by Arthur M. Schlesinger, Jr.,
and printed 425 copies on a hand-operated press in his parent's basement.

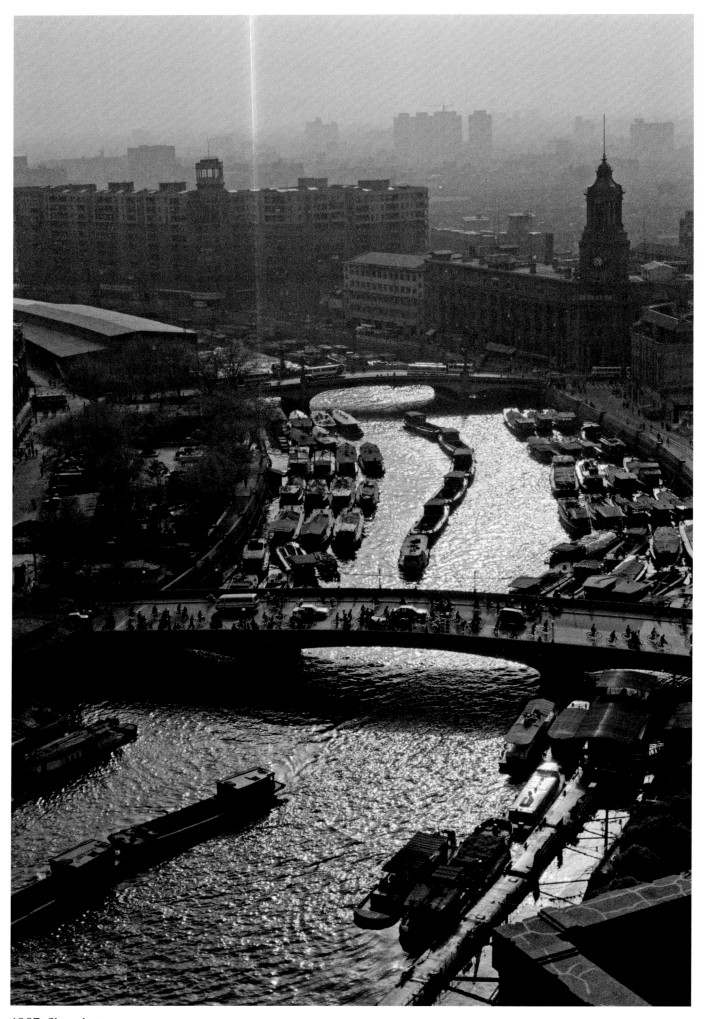

1987 Shanghai
The General Post Office building, on the right, dominates
the view of Suzhou Creek as it cuts through the center of Shanghai.

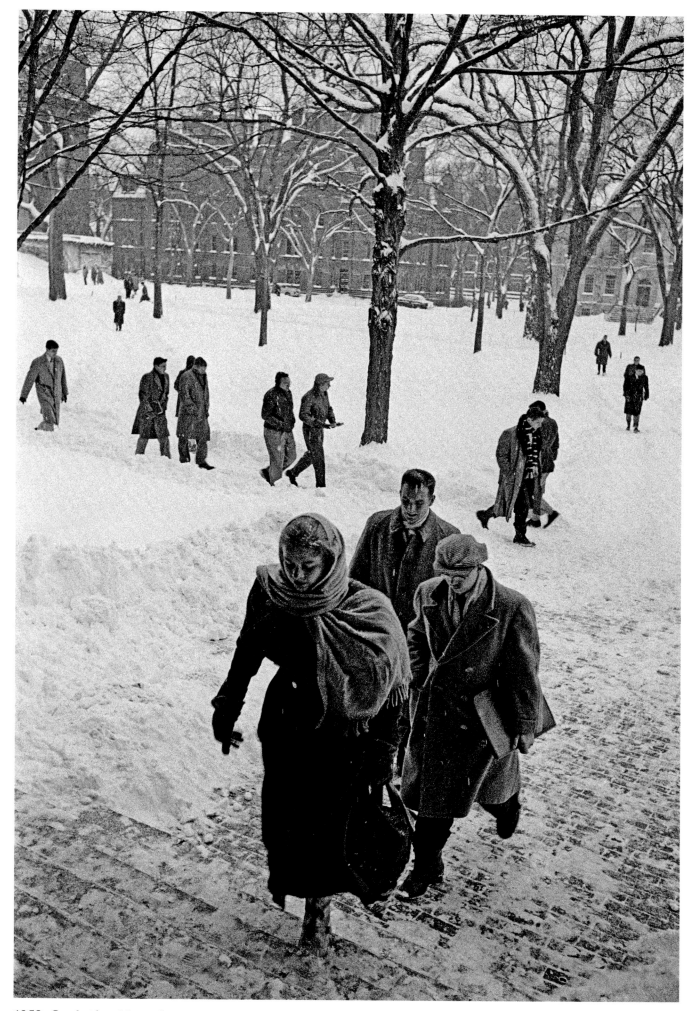

1953 Cambridge, Massachusetts
Students arrive for 10 o'clock classes in Sever Hall.

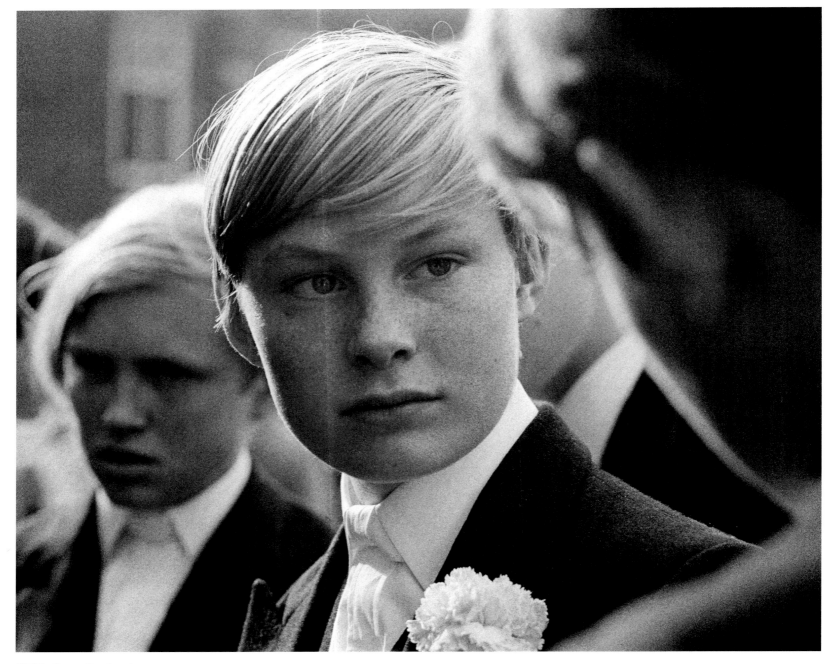

1968 Eton, England
Students wait to greet relatives on visitors' day at Eton College.

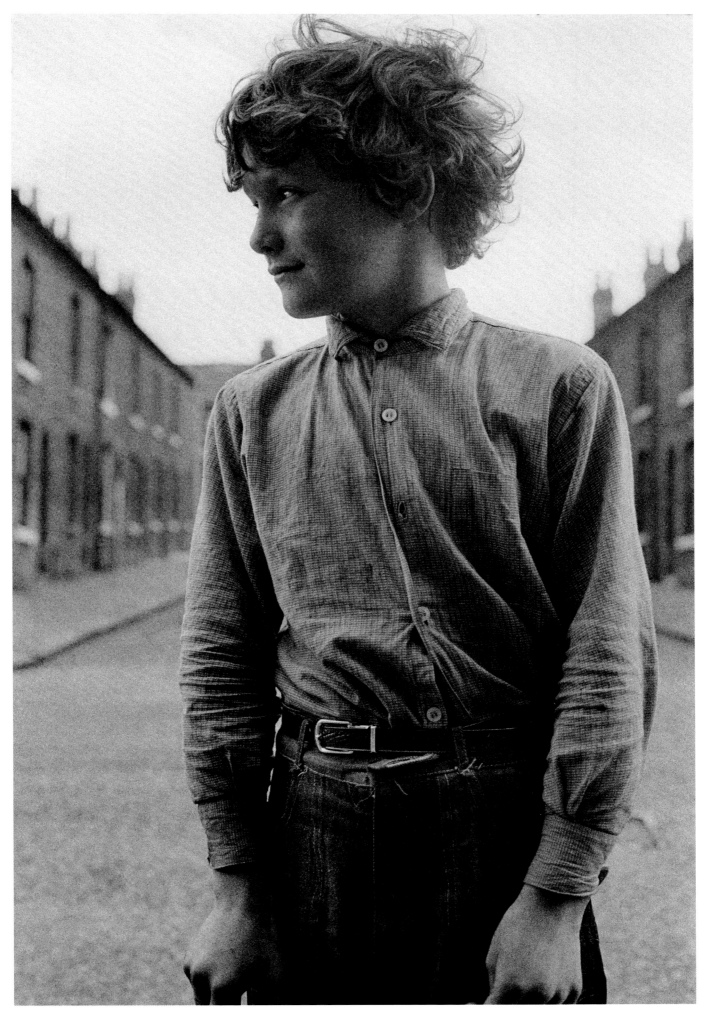

1968 Manchester, England
The boy turns his head as he hears his mother's call from down the street.

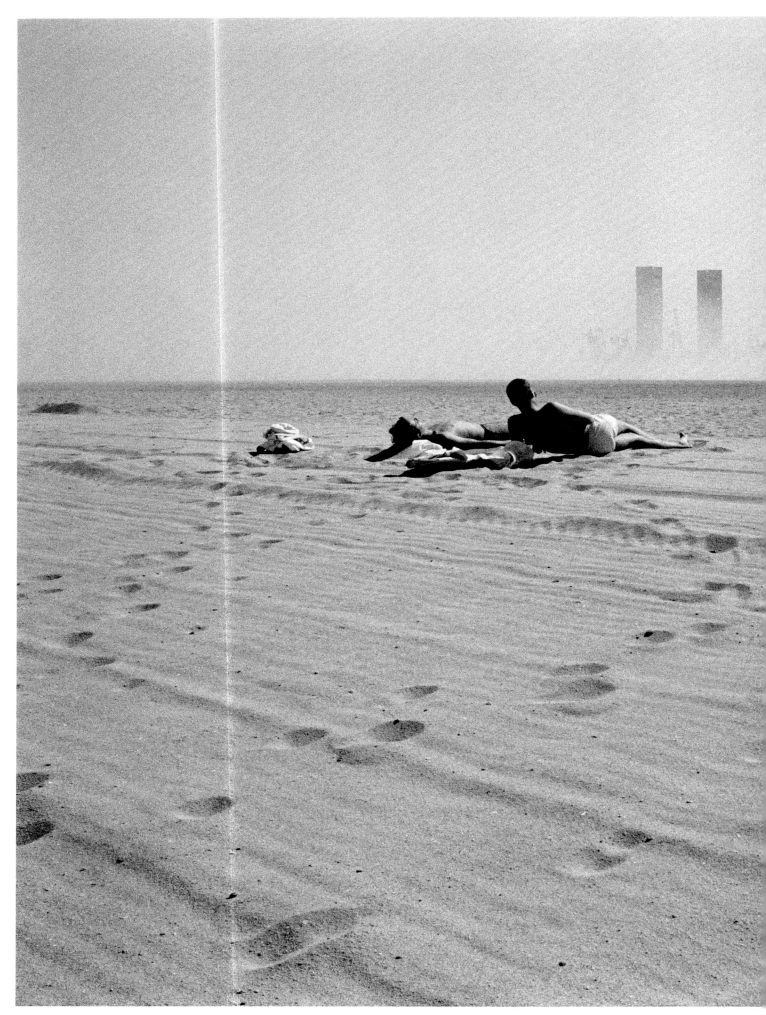

1969 Long Beach, California
Mandated to use a portion of its oil revenue to beautify the city,
Long Beach has disguised offshore oil derricks to resemble high-rise buildings.

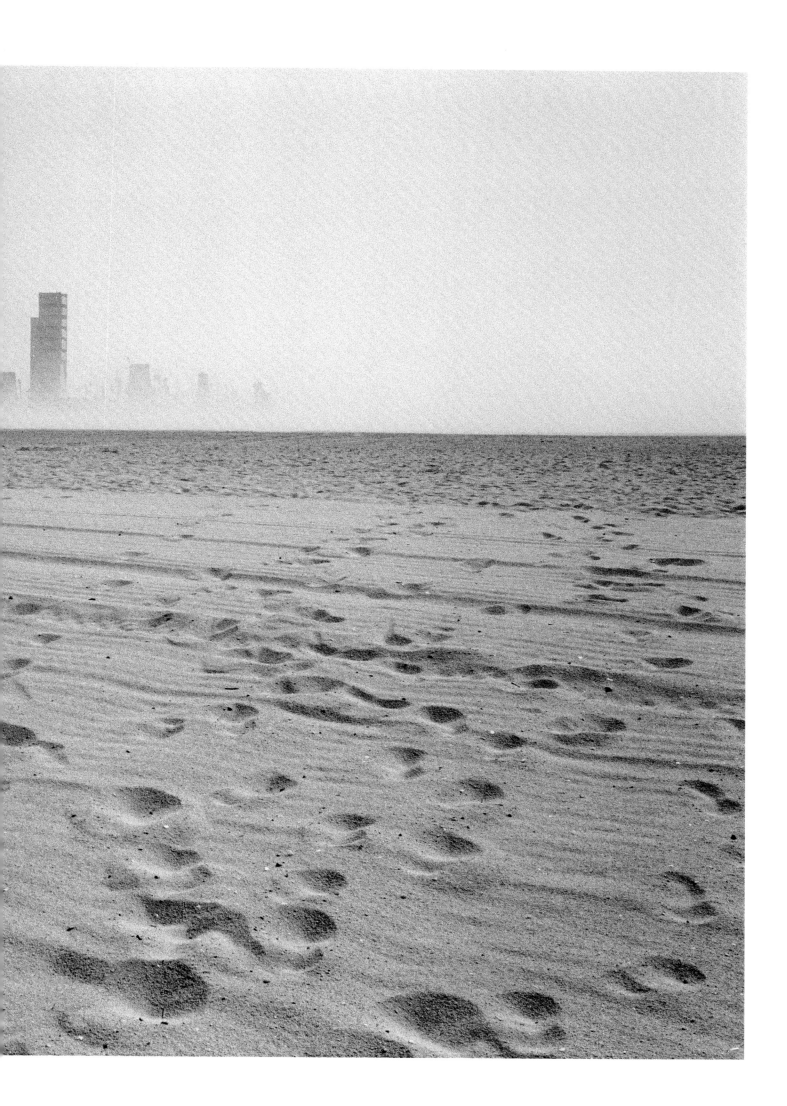

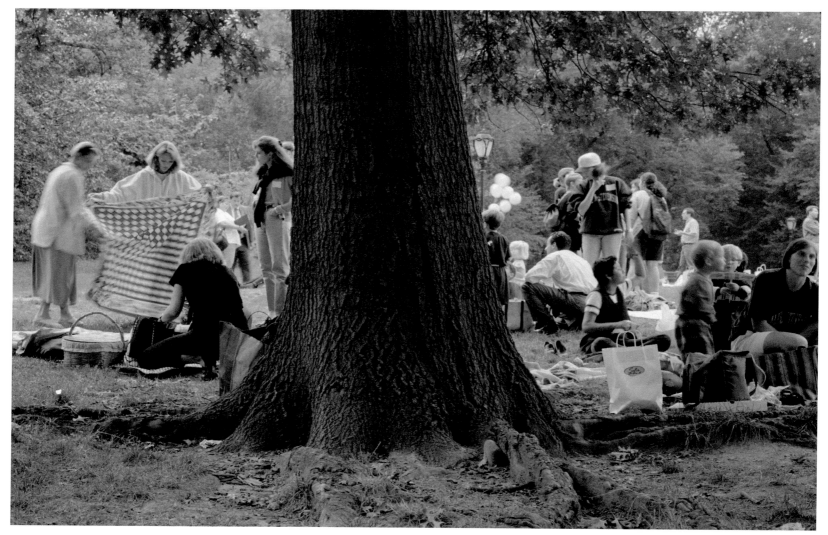

1996 New York City
A private school's kindergarten class has a picnic.

1960 New York City
Springtime arrives near the 79th Street transverse.

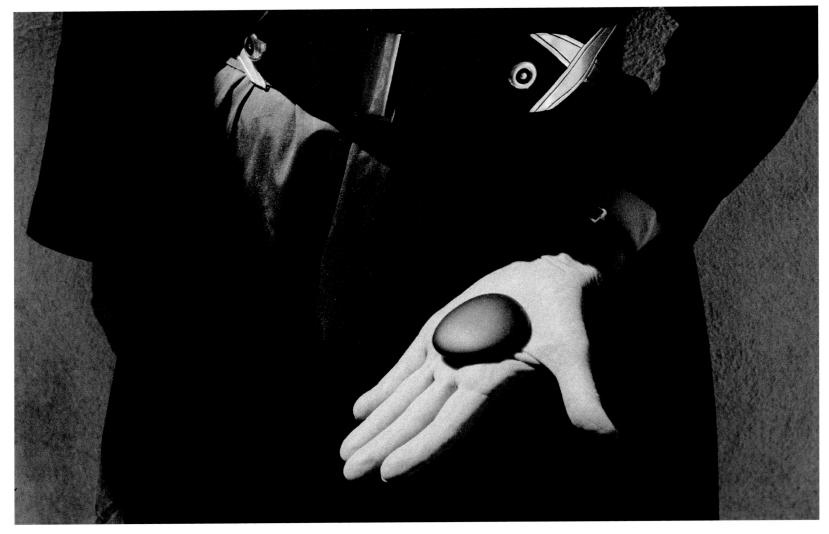

1966 Abiquiu, New Mexico
Painter Georgia O'Keeffe tells me she stole her favorite stone from photographer Eliot Porter.

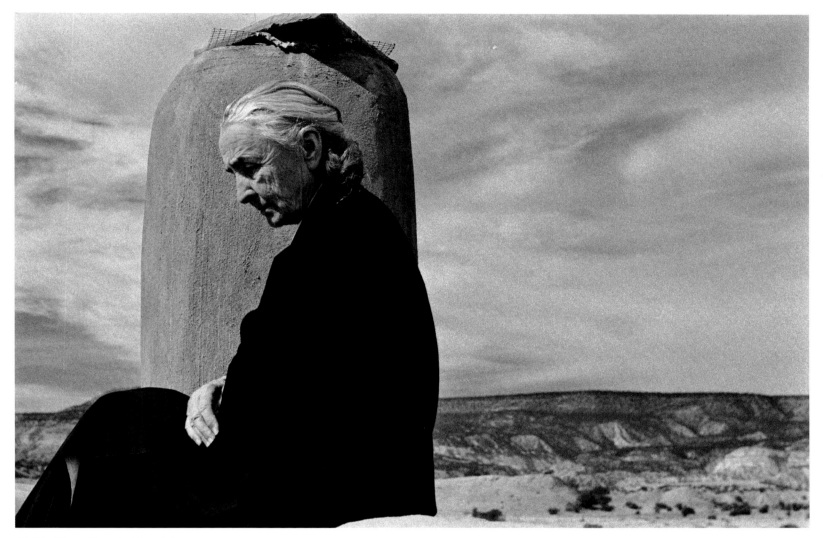

1967 Ghost Ranch, New Mexico
Georgia O'Keeffe is on the roof of her home at Ghost Ranch.

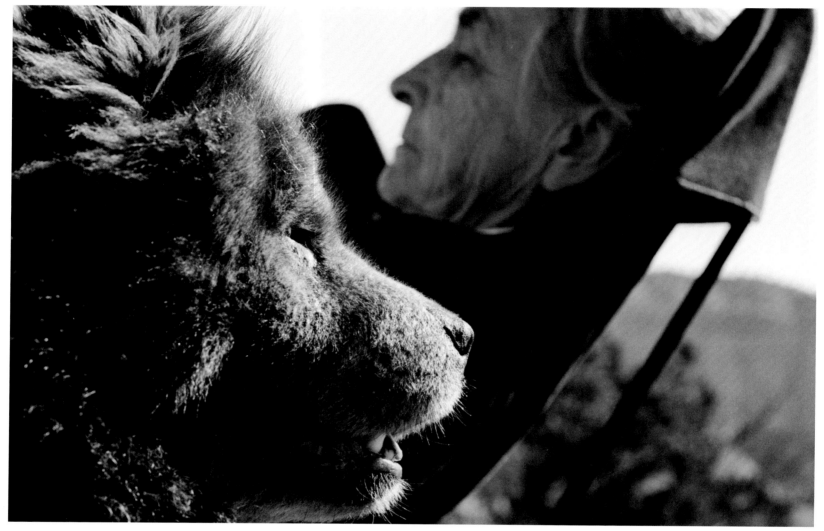

1966 Ghost Ranch
Georgia O'Keeffe sits with her chow dog.

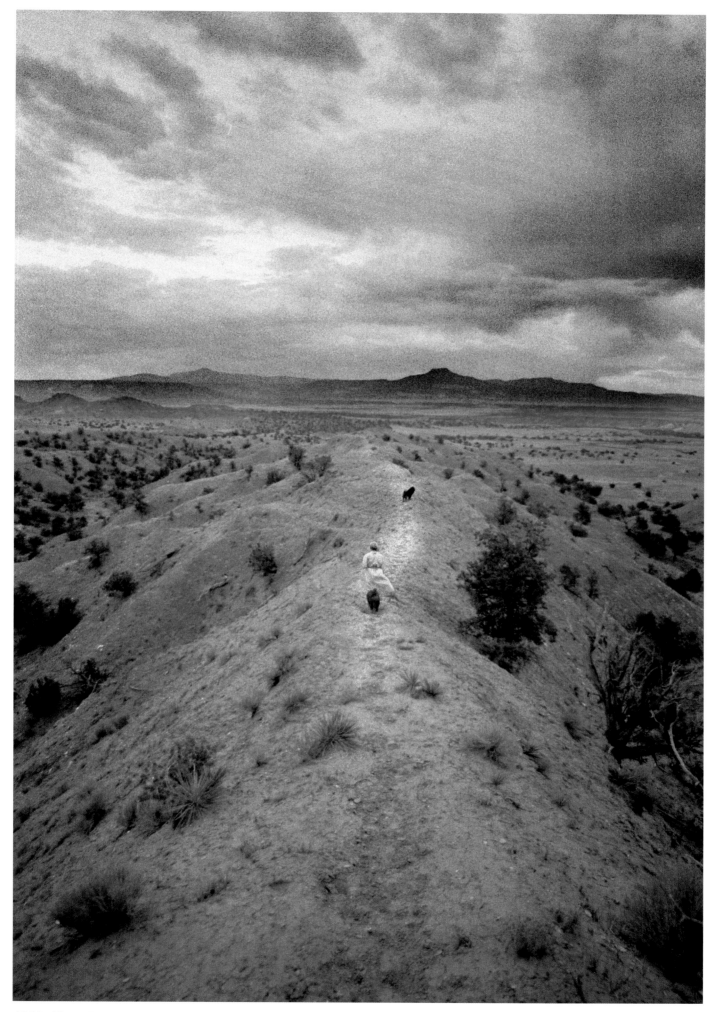

1966 Ghost Ranch
With both her dogs, O'Keeffe takes a sunset walk over the red hills that surround Ghost Ranch.

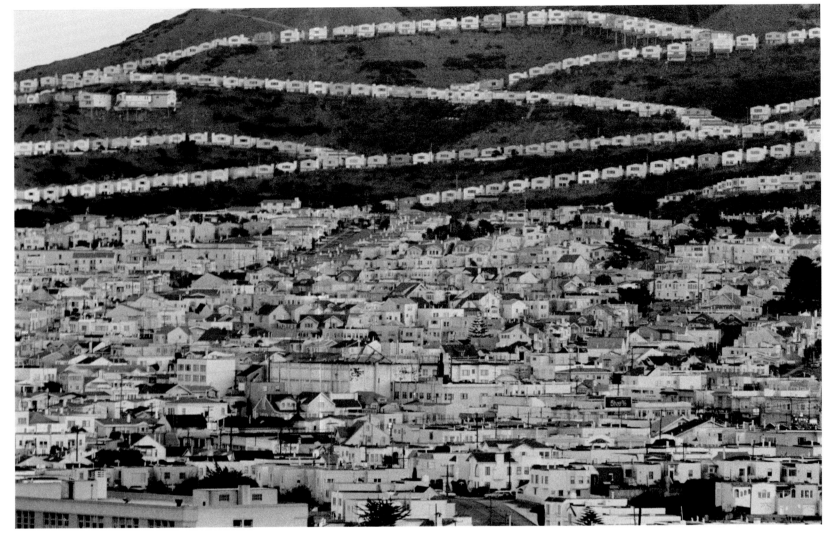

1969 Daly City, California
Newly built homes climb the hills south of San Francisco.

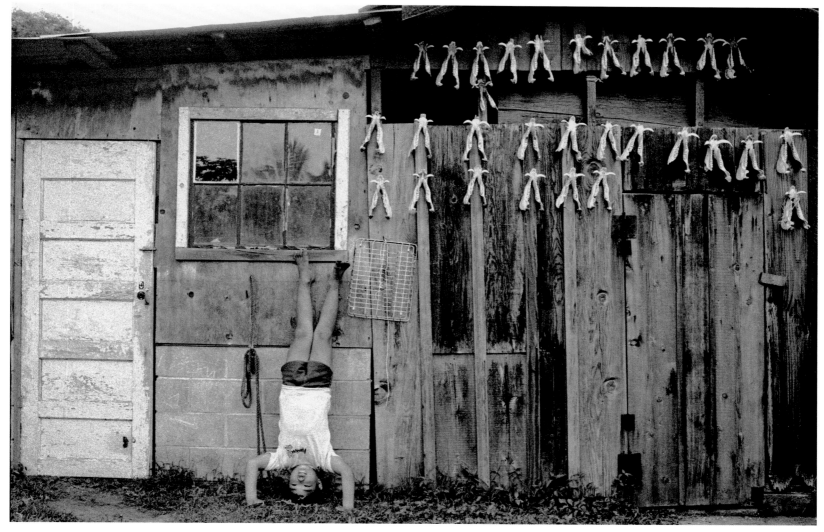

1983 Big Island, Hawaii
Calbert Imada's dad hunts feral pigs, and their jawbones line the shed.

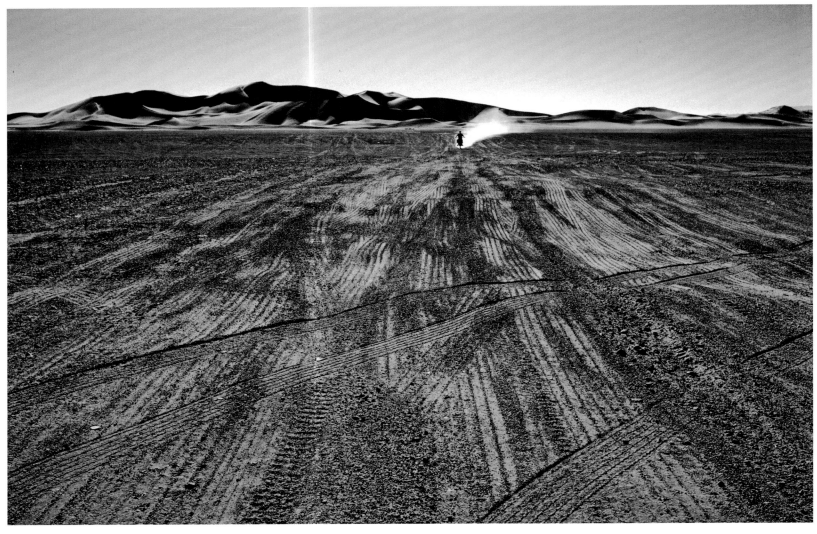

1970 Dumont Dunes, California
Tracks of dune buggies, cycles, and four-wheel drive vehicles have cracked the crust of the Mojave Desert.

1979 Outside Sydney, Nova Scotia
The law in Canada requires drivers to have their headlights on in daylight.

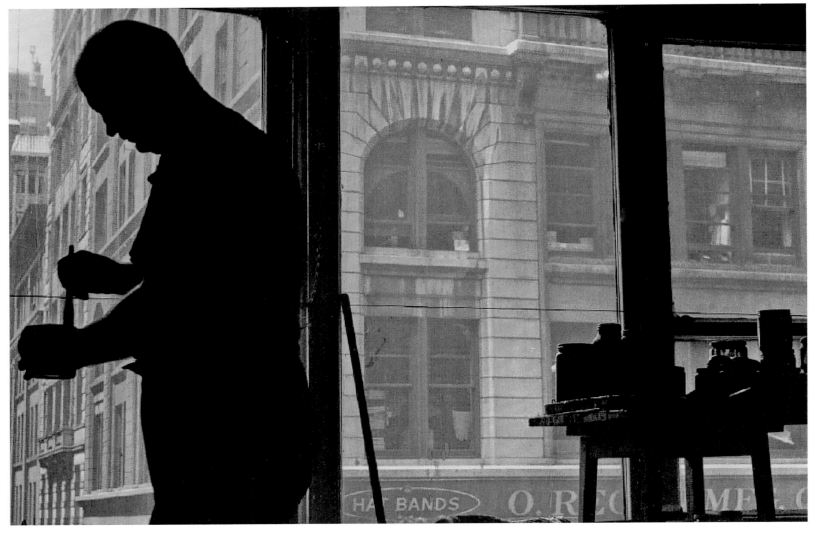

1966 New York City
Ad Reinhardt mixes bits of red (or blue or green) paint with black pigment in a jar.
He pours off the jar's turpentine in a week or two, leaving behind the matte, near-black paint he wants.

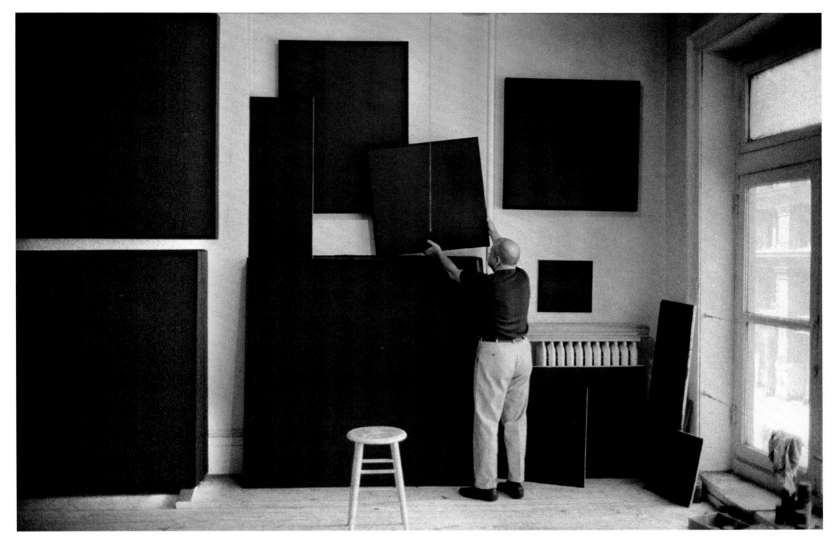

1966 New York City
The eye needs minutes to adjust before it makes out the red, blue,
or greenish rectangles that make up Reinhardt's "black" paintings.

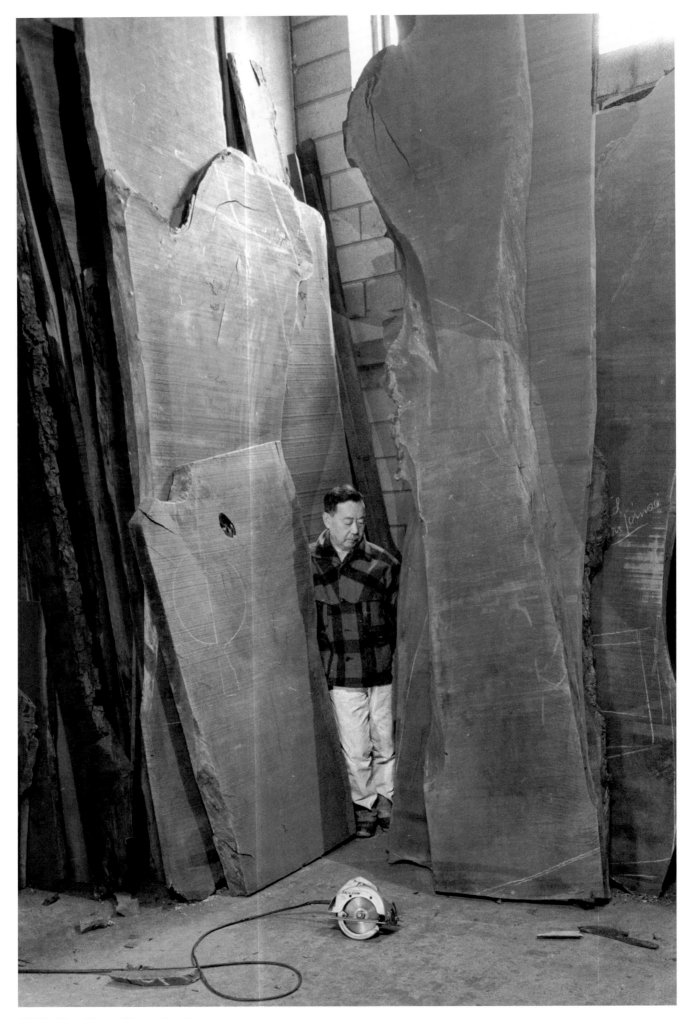

1969 New Hope, Pennsylvania
George Nakashima bids on slices of rare trees sold at auctions around the world
and uses them to make furniture that often retains the wood's natural contours.

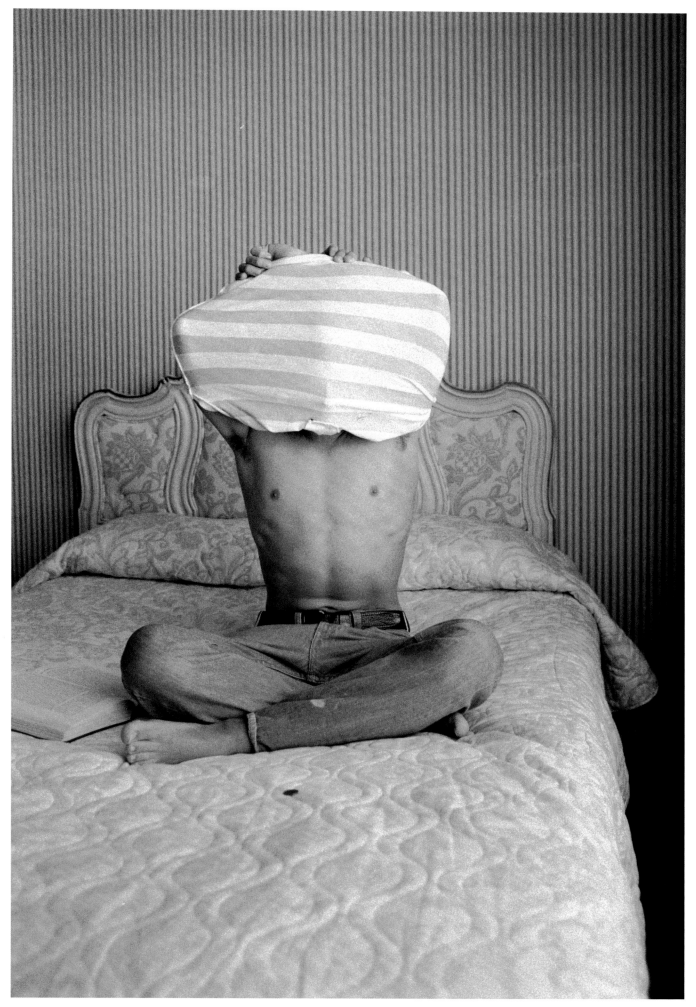

1980 Miami Beach, Florida
On a spring break, my son, Charles, fifteen, changes his shirt at the Fontainebleau Hotel.

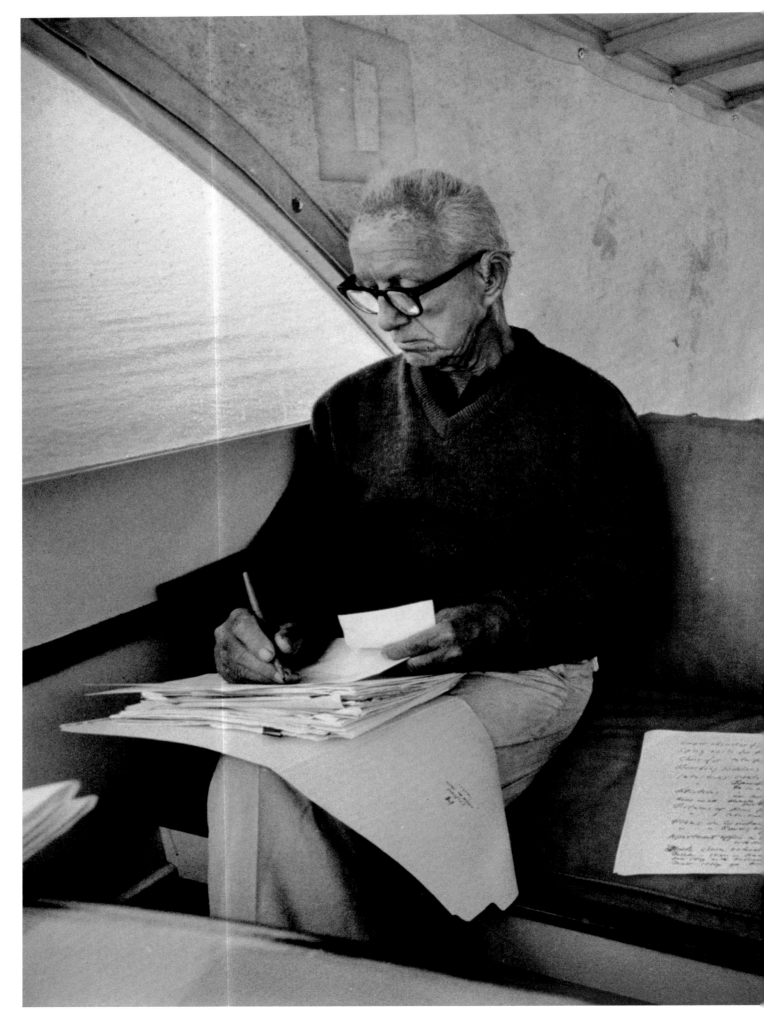

1970 Penobscot Bay, Maine
Buckminster Fuller, champion of geodesic domes, ferries houseguests to Bear Island,
which his grandmother bought in 1904. It remains his family's summer seat.

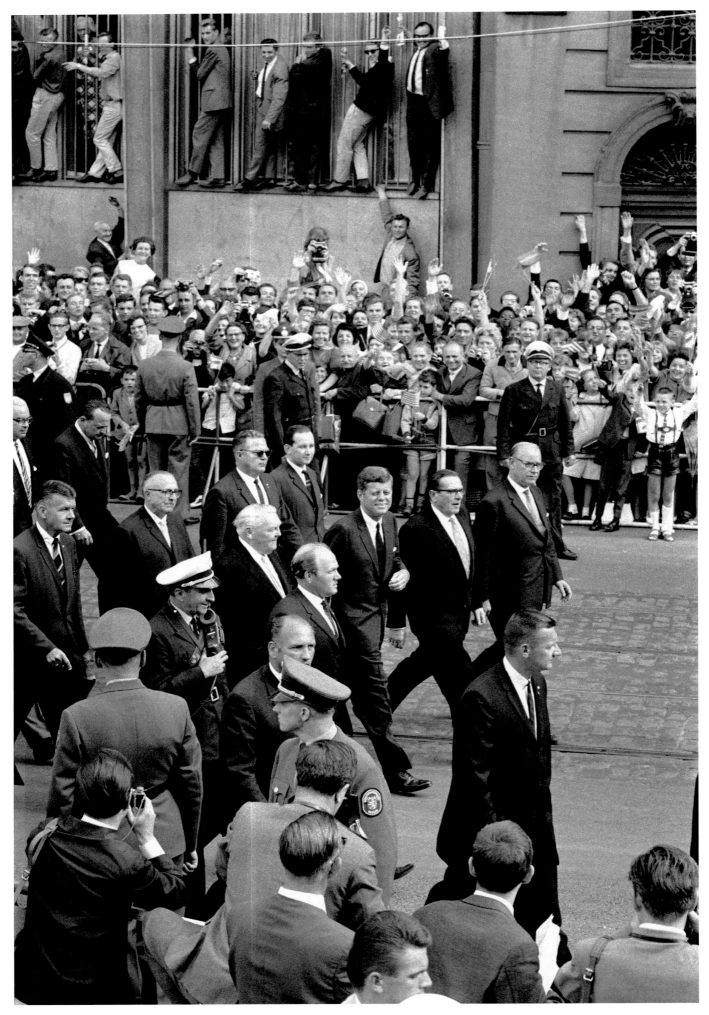

1963 Frankfurt, Germany
German officials lead President John F. Kennedy through Frankfurt on his way
to Berlin. He has been practicing the phrase *Ich bin ein Berliner.*

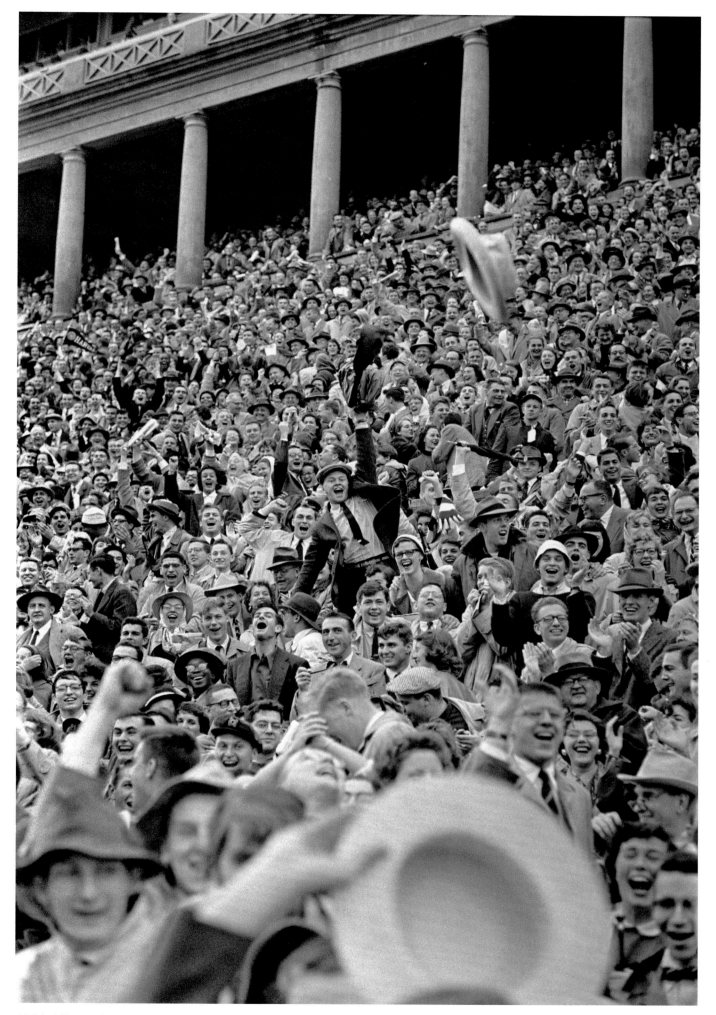

1954 Allston, Massachusetts
Harvard scores a touchdown, with four minutes left in the game, to lead Yale 13–9.

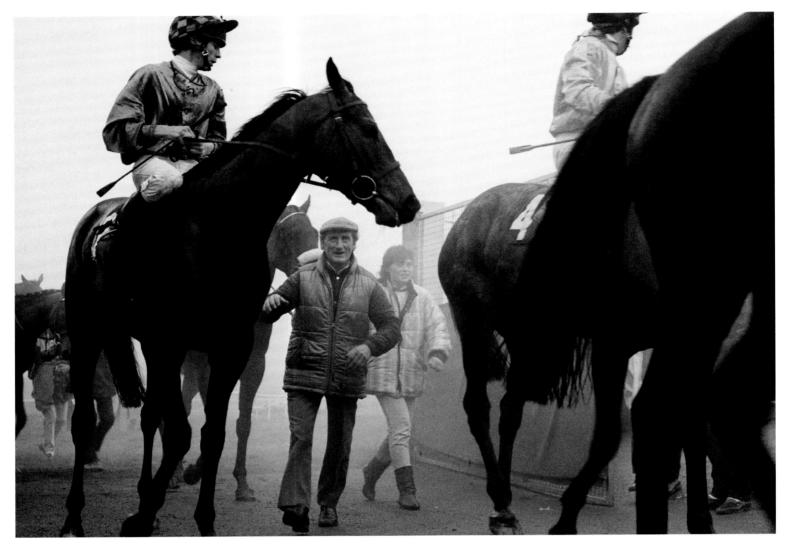

1987 Dublin
Trainers greet jockeys and their horses at the end of a race.

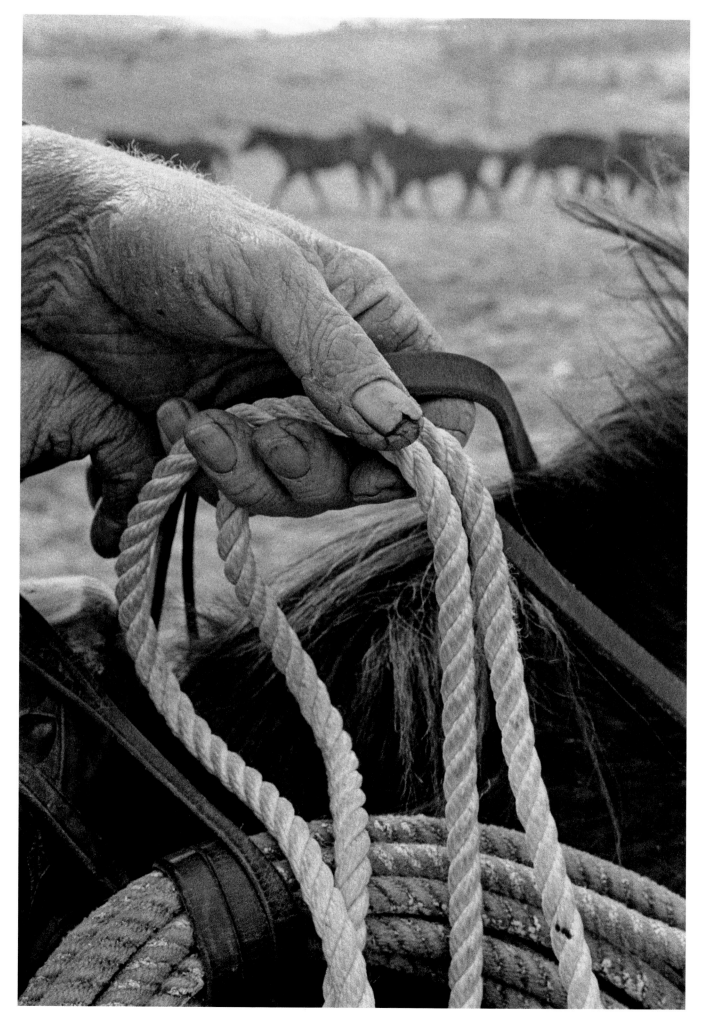

1970 near Prescott, Arizona
On a winter morning, ranch foreman Whistle Mills oversees feeding the horses.

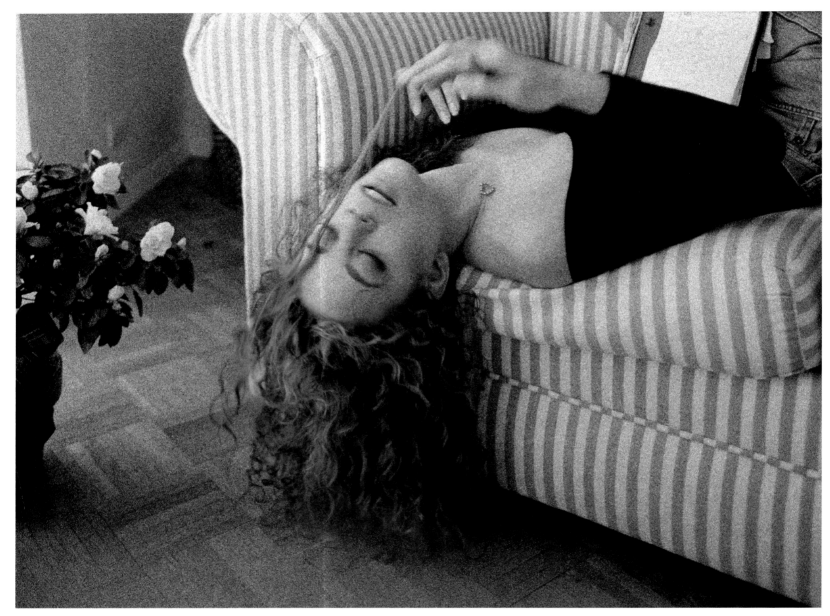

1990 New York City
People magazine bills Mariah Carey as "pop's top-ranking rookie diva."
She relaxes in a friend's Manhattan apartment.

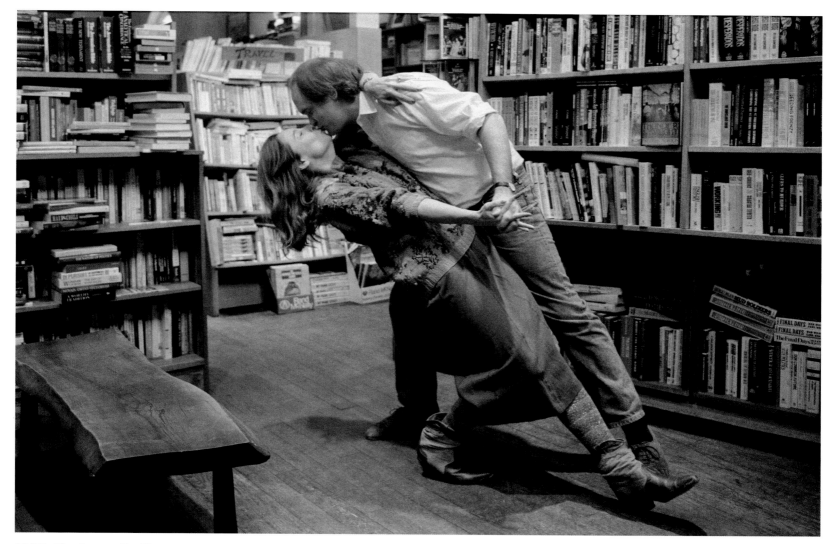

1990 Charlottesville, Virginia
Author Ann Beattie and her husband, painter Lincoln Perry,
like to annoy their friend Michael Williams by making out in his bookstore.

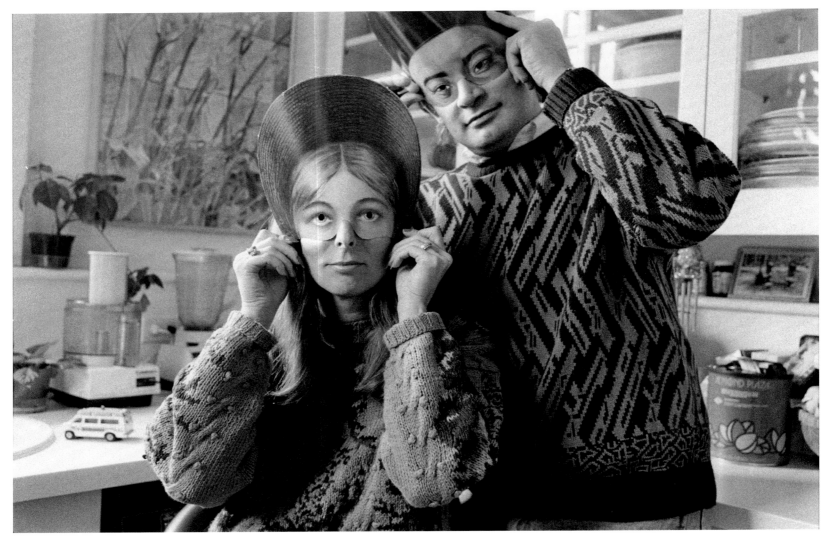

1990 Charlottesville
Ann Beattie and Lincoln Perry prepare for Halloween.

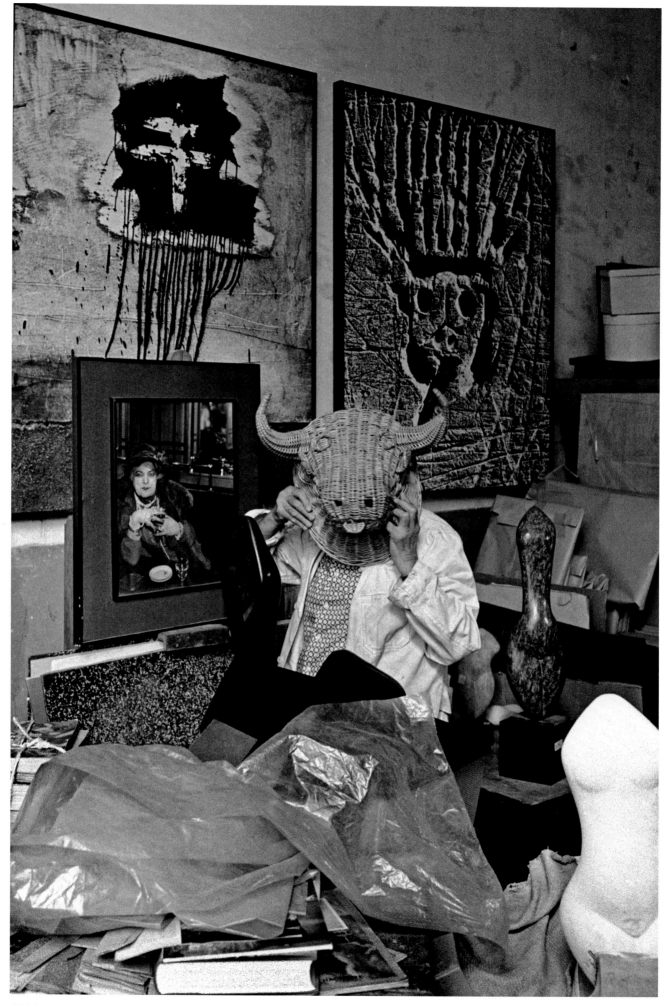

1981 Paris
For a moment in his studio, the photographer known as Brassaï becomes a Minotaur.

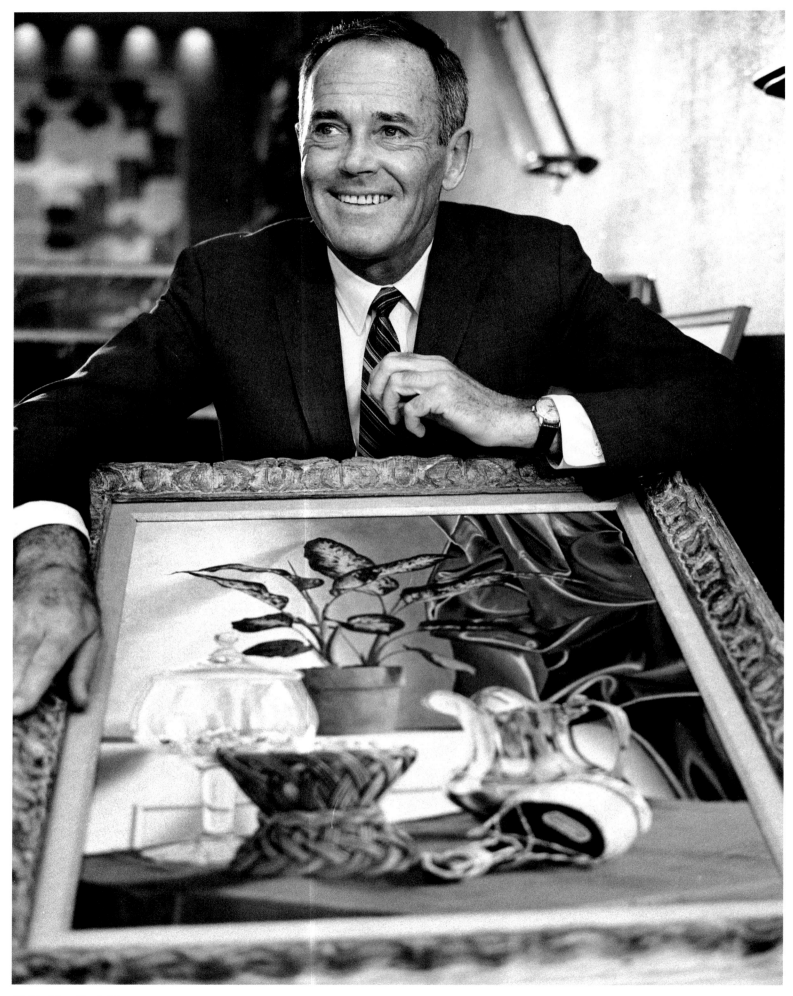

1963 New York City
For charity this evening, actor Henry Fonda will auction off a painting he has made.

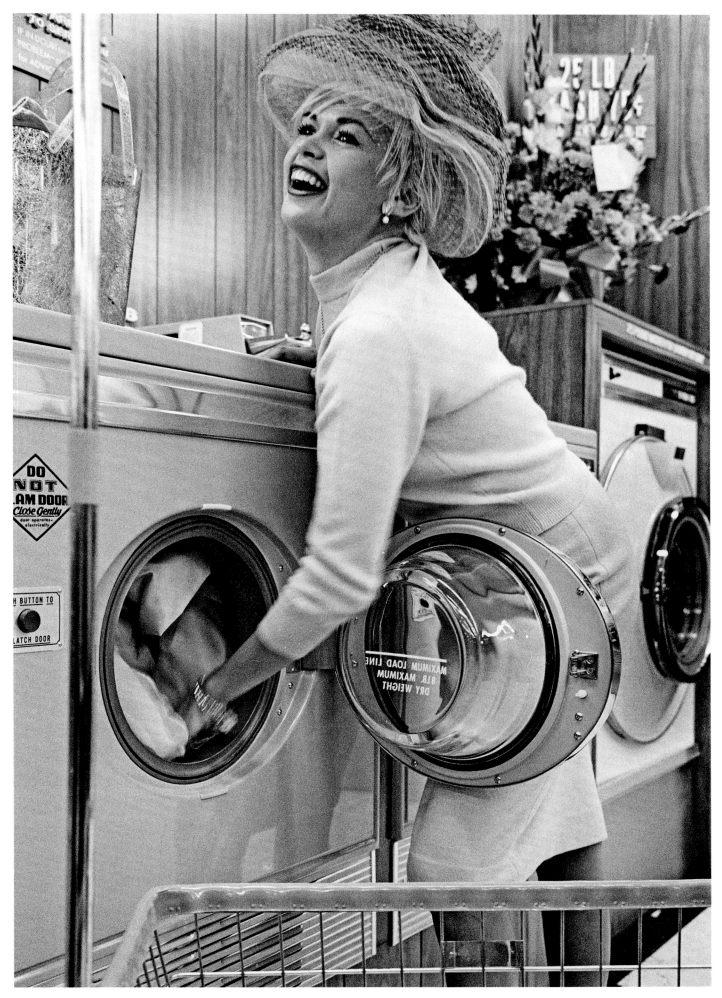

1962 Los Angeles
Actress Jayne Mansfield turns up at the opening of a coin-operated dry cleaner.

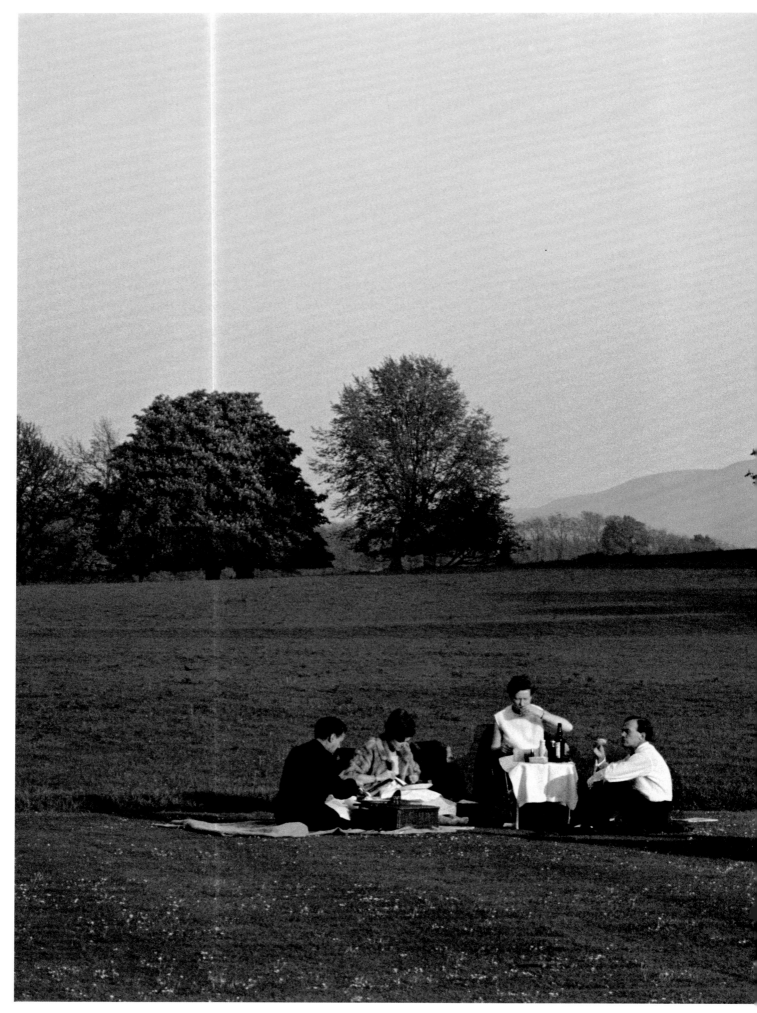

1968 Glyndebourne, England
Members of the audience picnic during supper intermission at the Glyndebourne Opera.

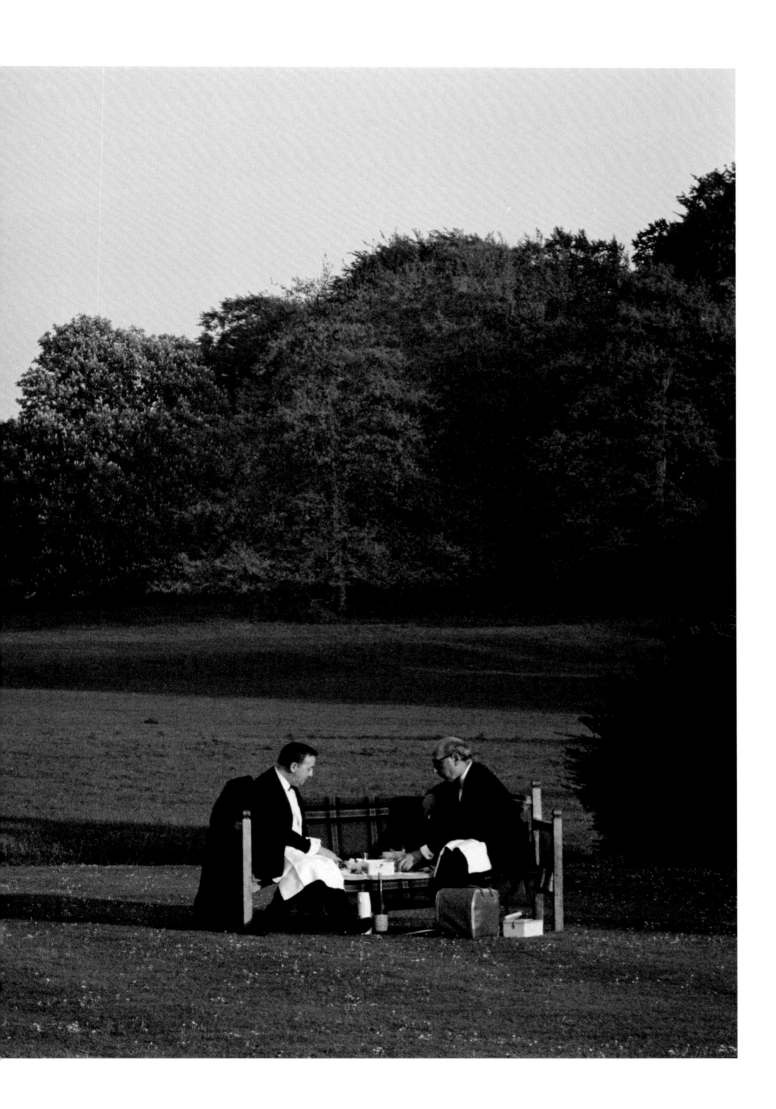

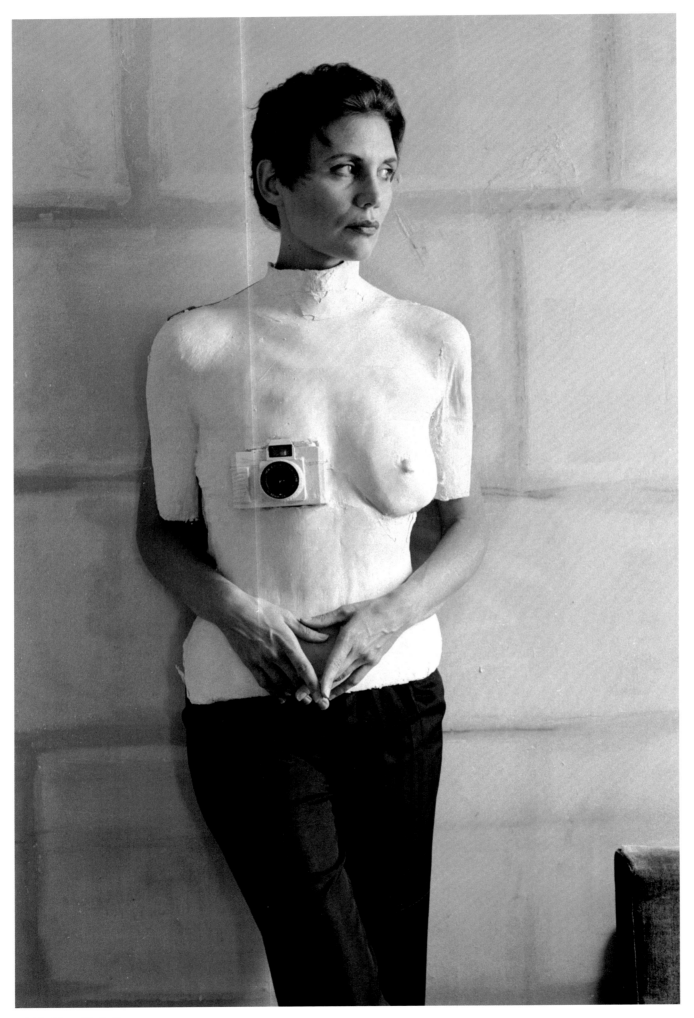

1993 New York City
An activist for breast cancer research and an artist, Matuschka says, "Breast cancer has defined my life and art."

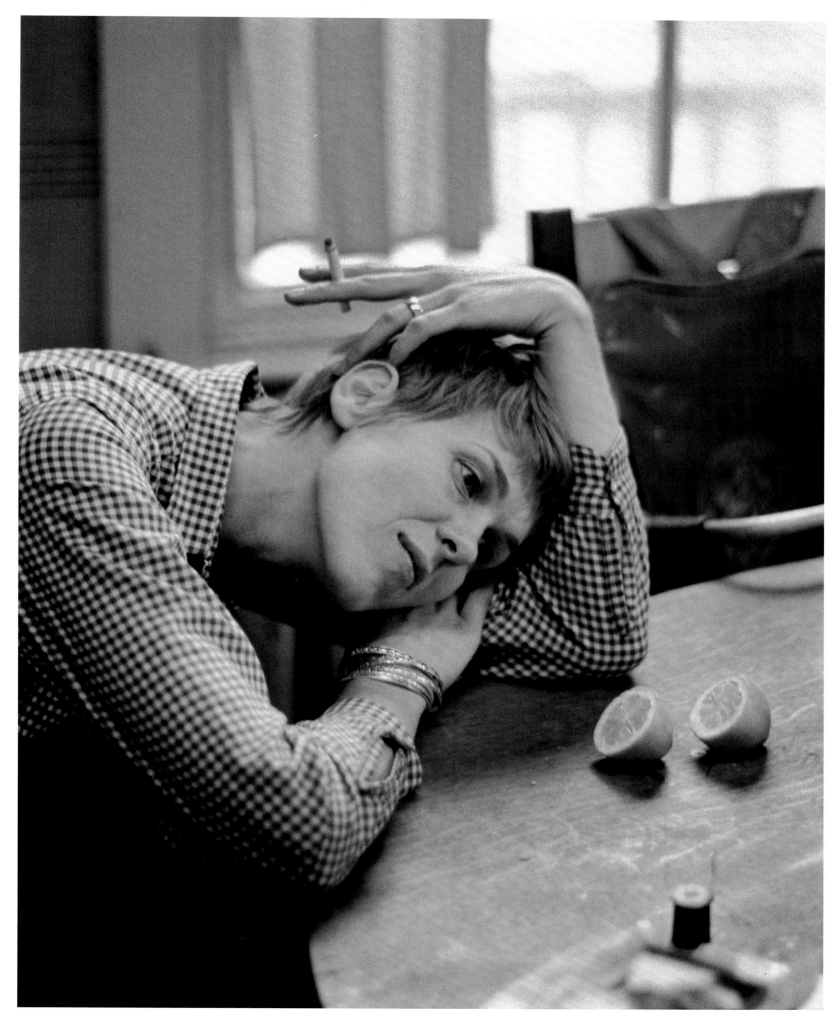

1963 Cambridge, Massachusetts
Housewife Barbara Dunlap takes part in a study of the effect of LSD on healthy individuals.

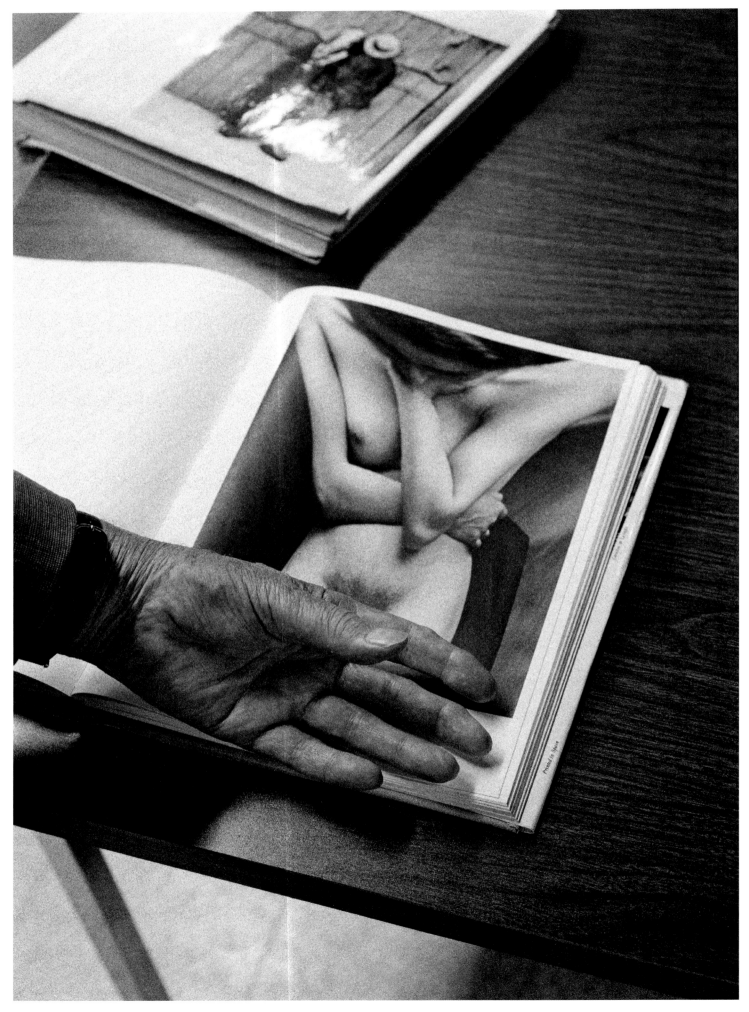

1981 New York City
The public display of pubic hair was illegal in New York City in 1937, so the Museum of Modern Art asked André Kertész to crop his photograph before they exhibited it. Still angry forty-four years later, Kertész indicates what the museum asked him to do.

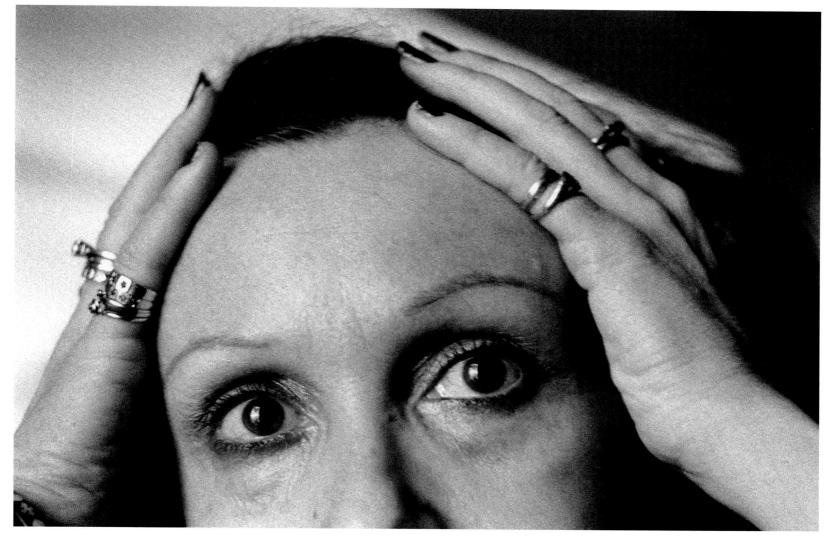

1982 New York City
Jill Gill, who does portraits in watercolor and ink of streetscapes and
town houses, asks me to take her picture. I aim for the fingers and rings.

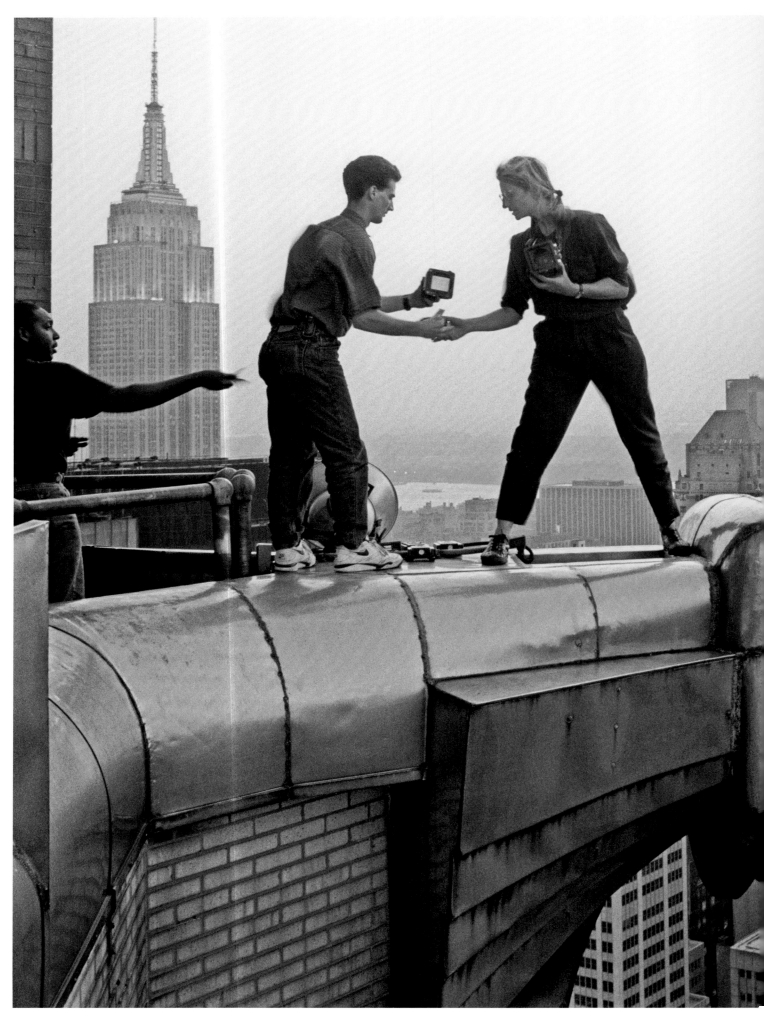

1991 New York City
Assistant Robert Bean hands Annie Leibovitz fresh film as she takes pictures of dancer
David Parsons atop a gargoyle extending from the 61st floor of the Chrysler Building.

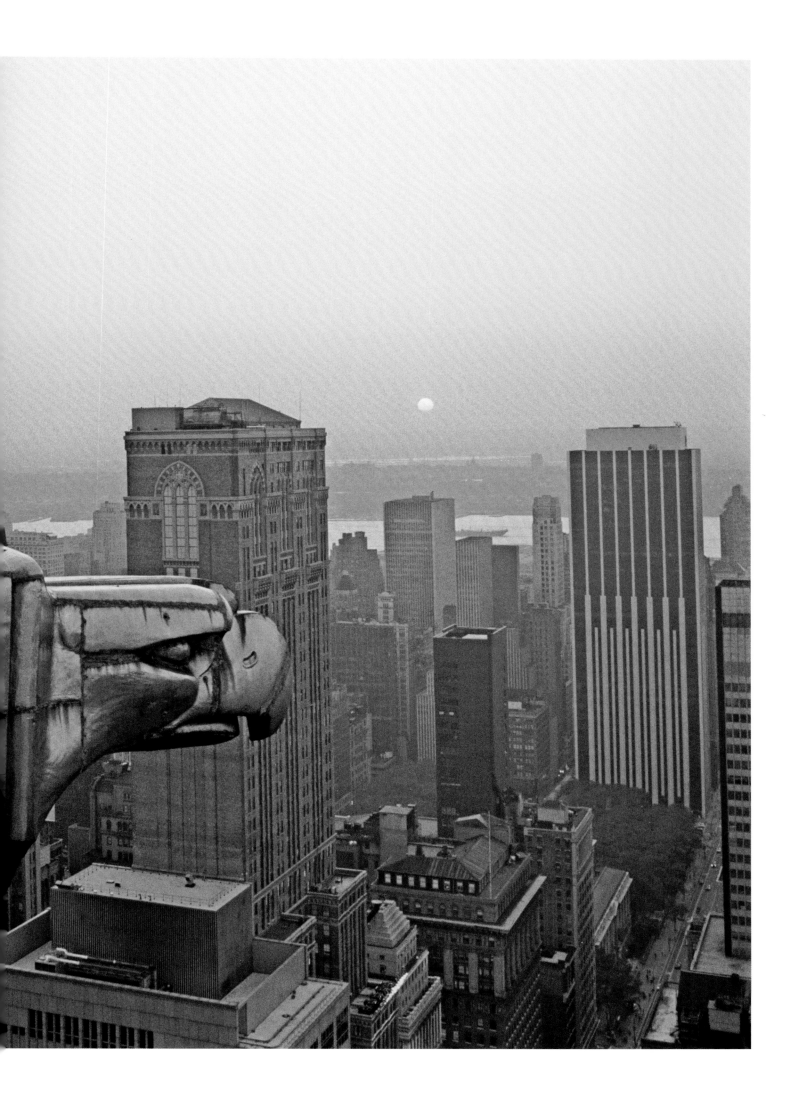

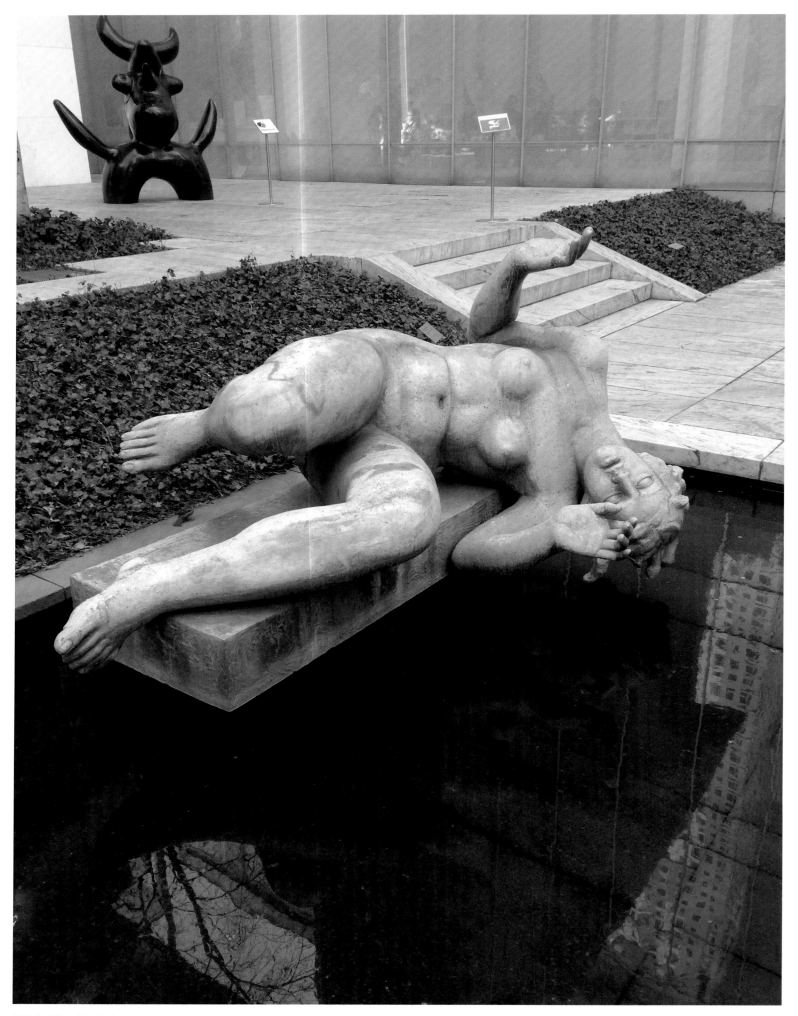

2015 New York City
Aristide Maillol finished the plaster model of *The River* in 1943, a year before he died.
It was cast in lead in 1948. Juan Miro's *Moon Bird* is behind it at the Museum of Modern Art.

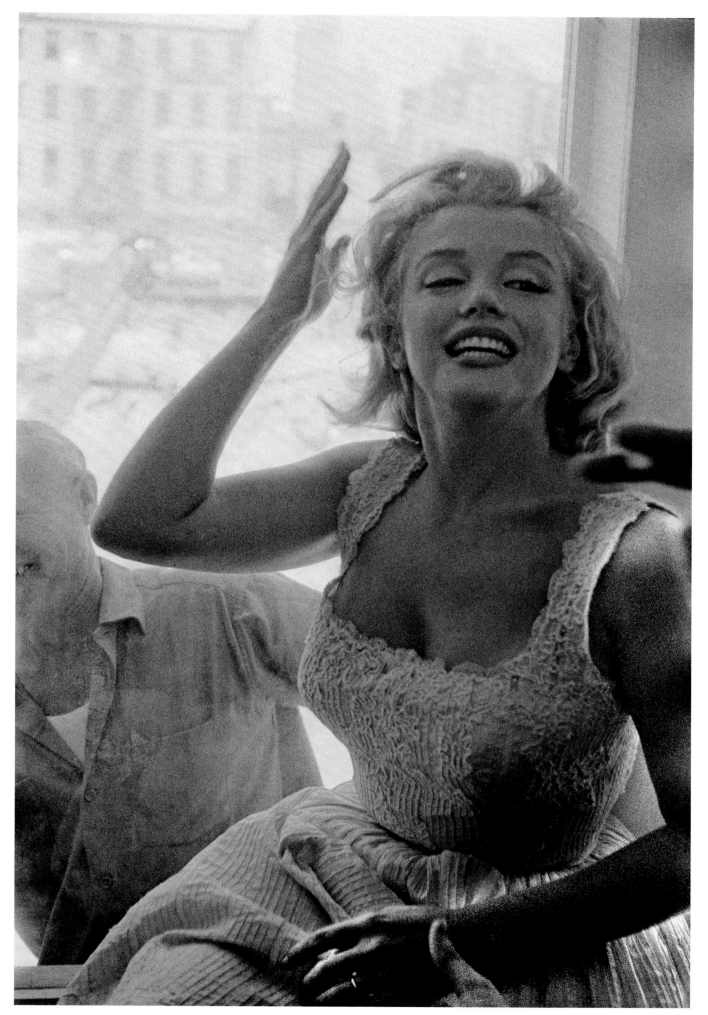

1957 New York City
Marilyn Monroe blesses the cornerstone-laying ceremony at the Time-LIFE building with her presence.

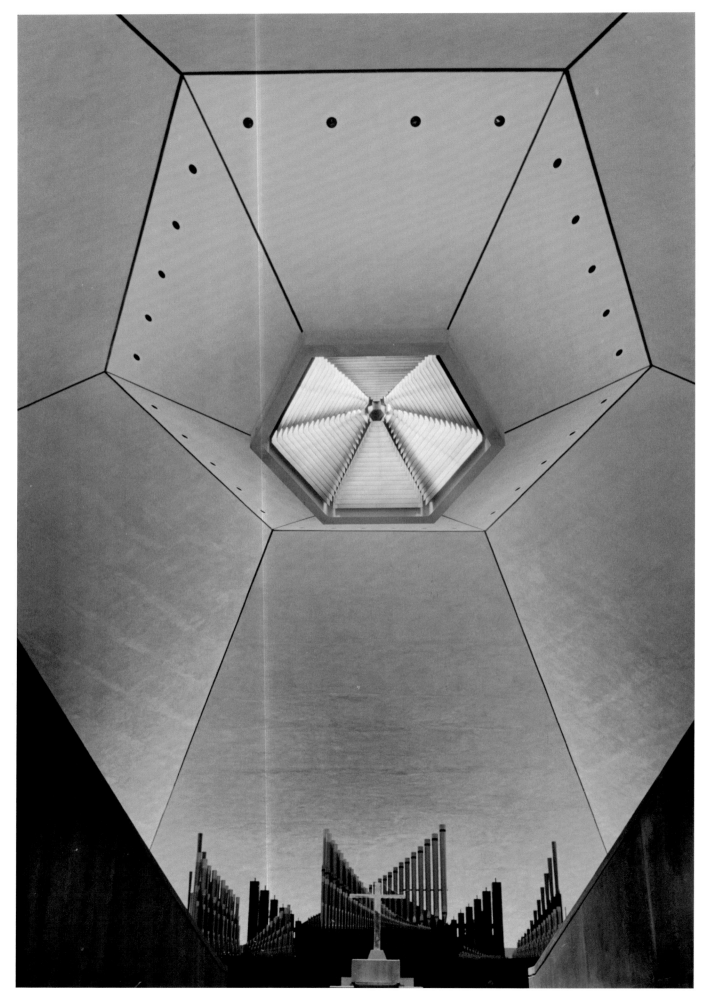

1967 Columbus, Indiana
Architect Eero Saarinen planned the spire atop the six-sided interior of his
North Christian church to be "a marvelous symbol of reaching upward to God."

1975 Philadelphia
A watchman makes his rounds in the first prison planned to induce penitence in inmates. Called a penitentiary, it was conceived in 1797, built in 1829, and used until 1971. It was not successful sponsoring contrition, but its spoke-and-wheel panopticon design was widely copied for its efficient use of guards.

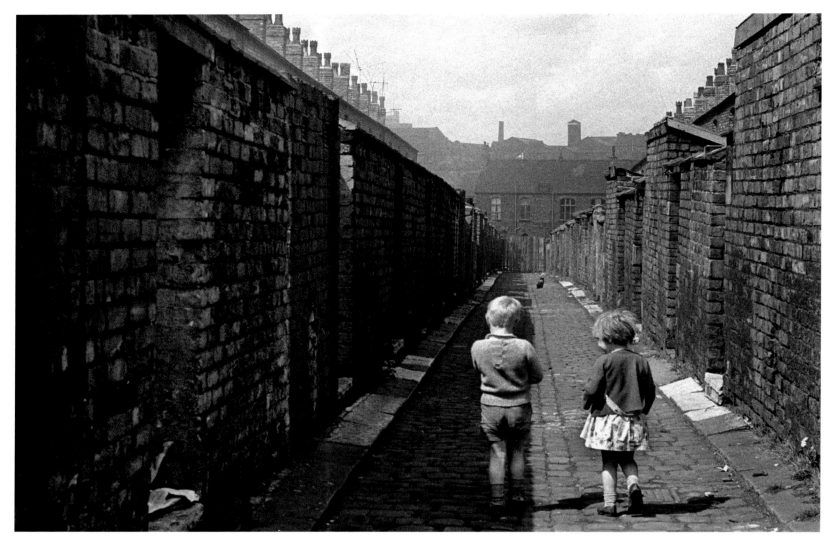

1968 Manchester
The alley runs along the backs of workers' houses.

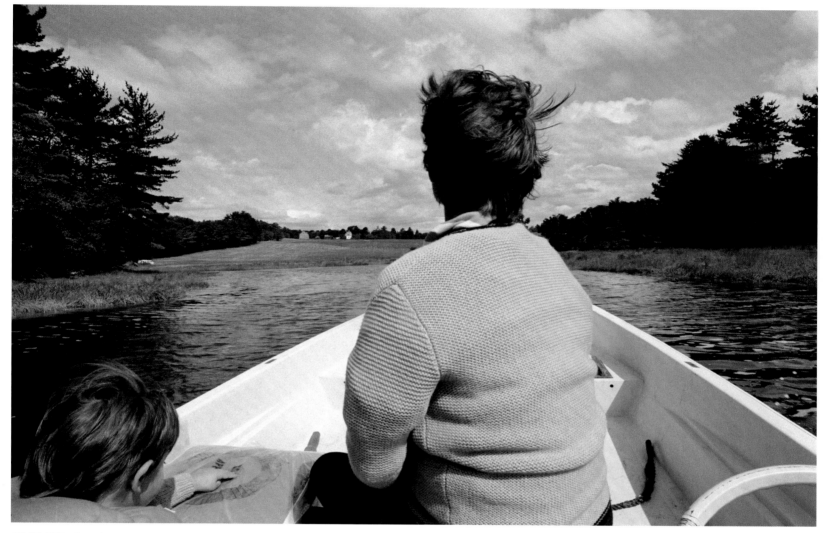

1967 Woolwich, Maine
Eleanor and our son, Charles, head toward our summer house.

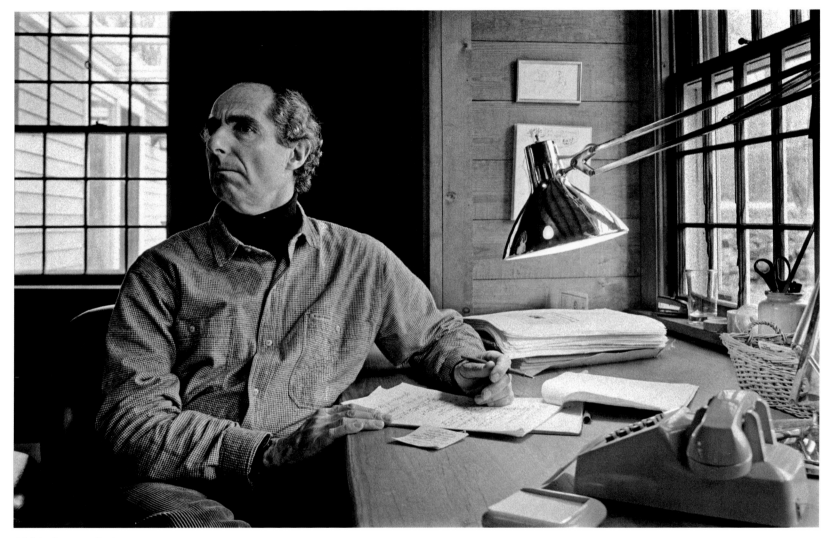

1991 Cornwall, Connecticut
In his writing cabin, novelist Philip Roth turns to answer a visitor's question.

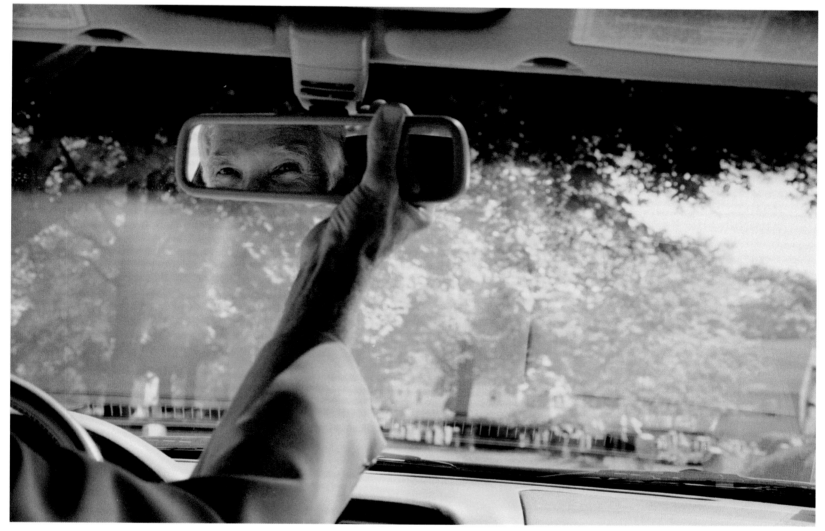

1999 Beverly Farms, Massachusetts
John Updike scans the suburbs and writes about the "wonderful mobility the auto has bestowed on this century."

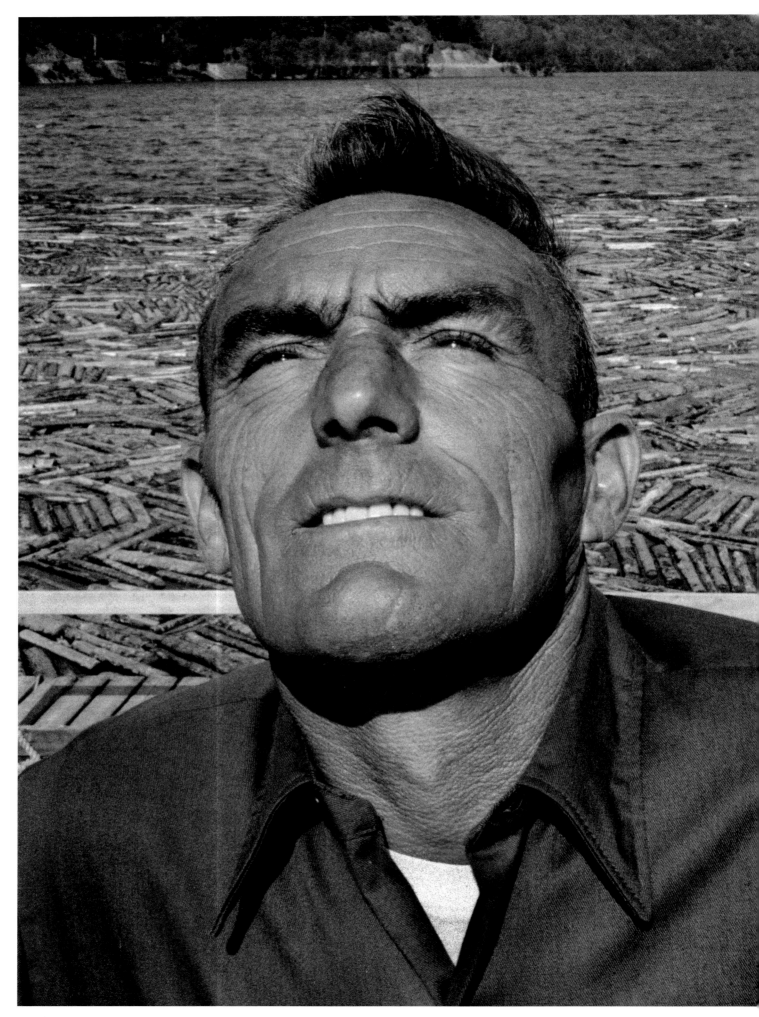

1975 Bingham, Maine
Leonard Violette, known as "Buster," is in charge of the last log drive allowed on Maine's Kennebec River.

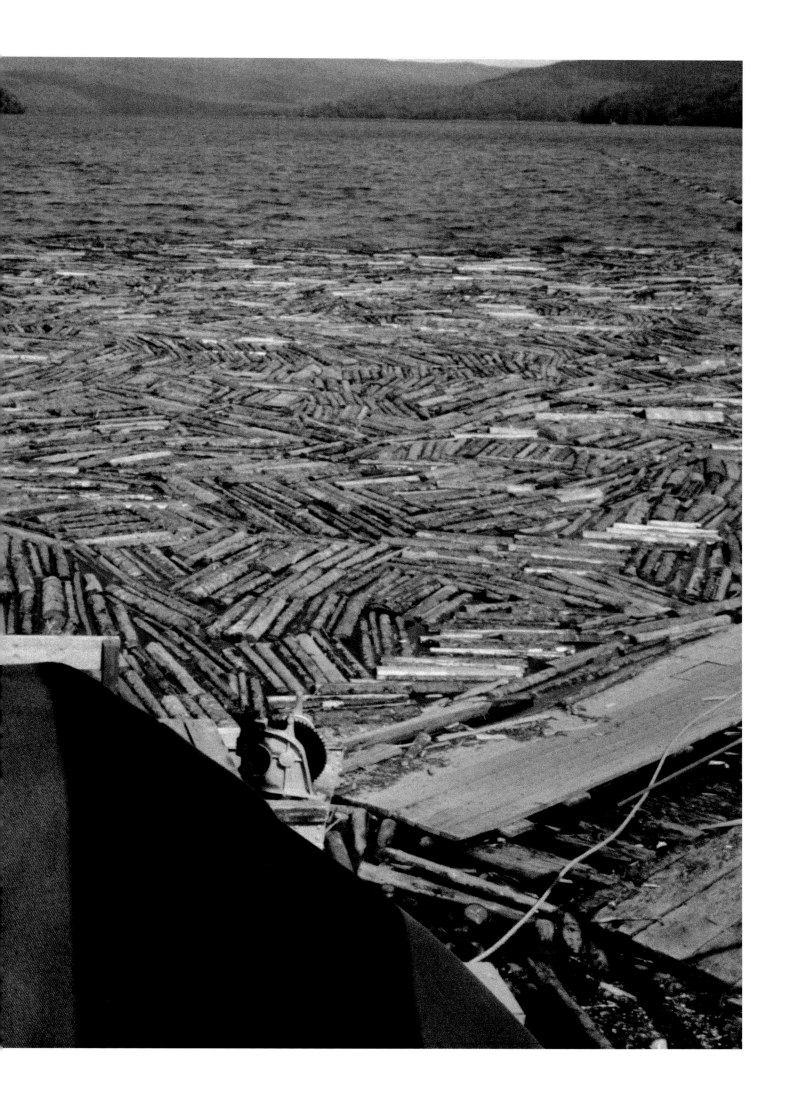

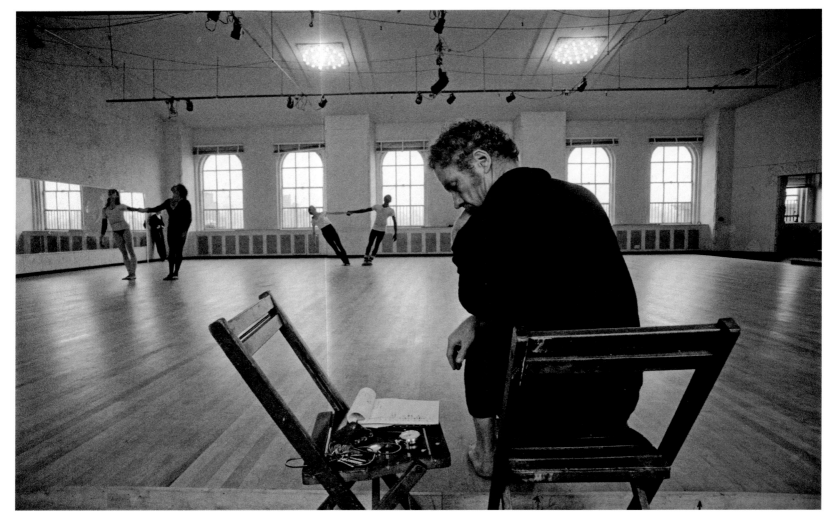

1971 New York City
Merce Cunningham rehearses his dance company in Westbeth,
the Bell Laboratories' scientific building that was converted last year to serve the arts.

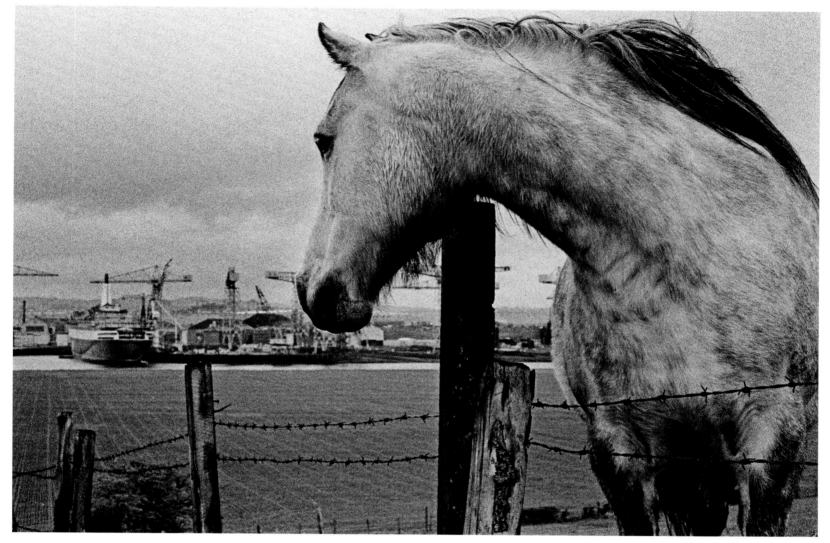

1968 Glasgow
The ocean liner *Queen Elizabeth II* is under construction across the River Clyde.

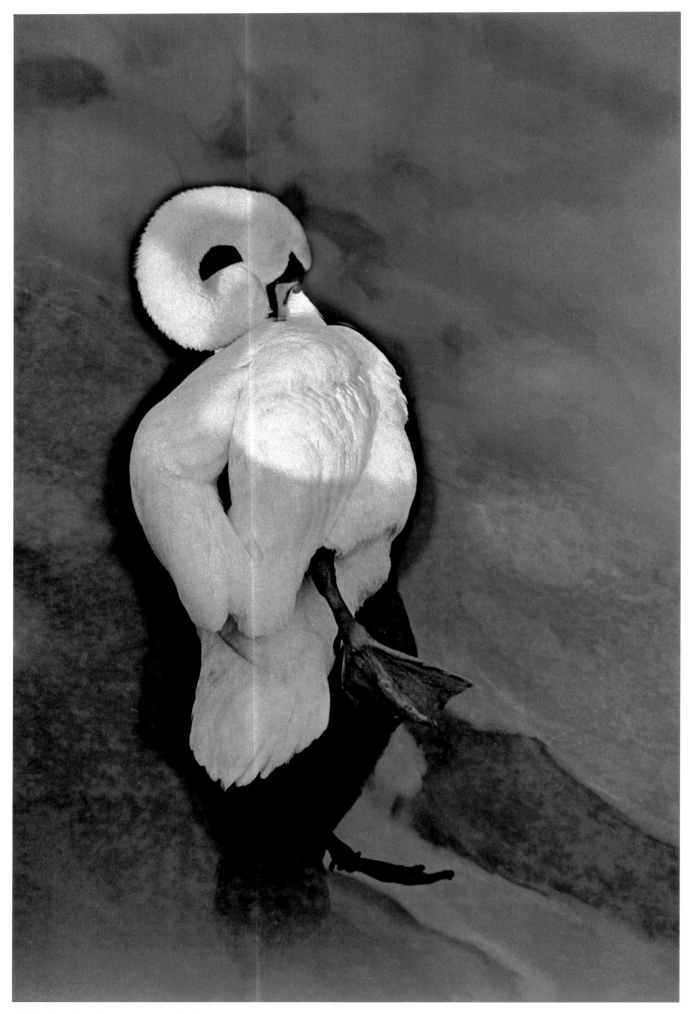

1968 Stratford-upon-Avon, England
A swan preens in a stream.

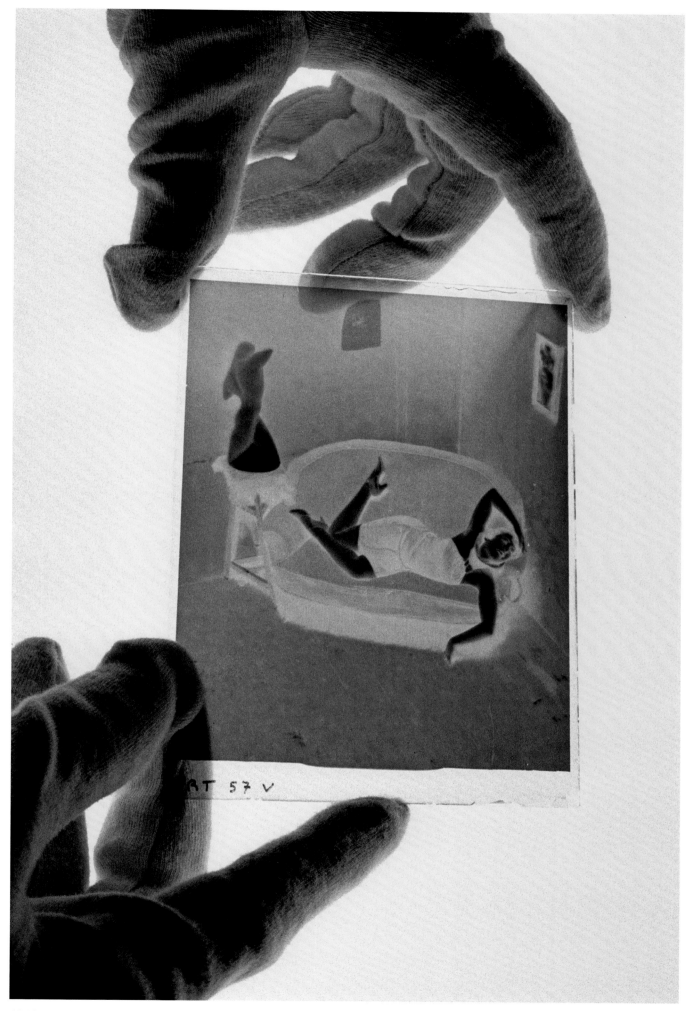

1993 Paris
André Kertész's negative (*Satiric Dancer,* 1926) is held by curator Noel Bourcier
at the Mission du Patrimoine Photographique.

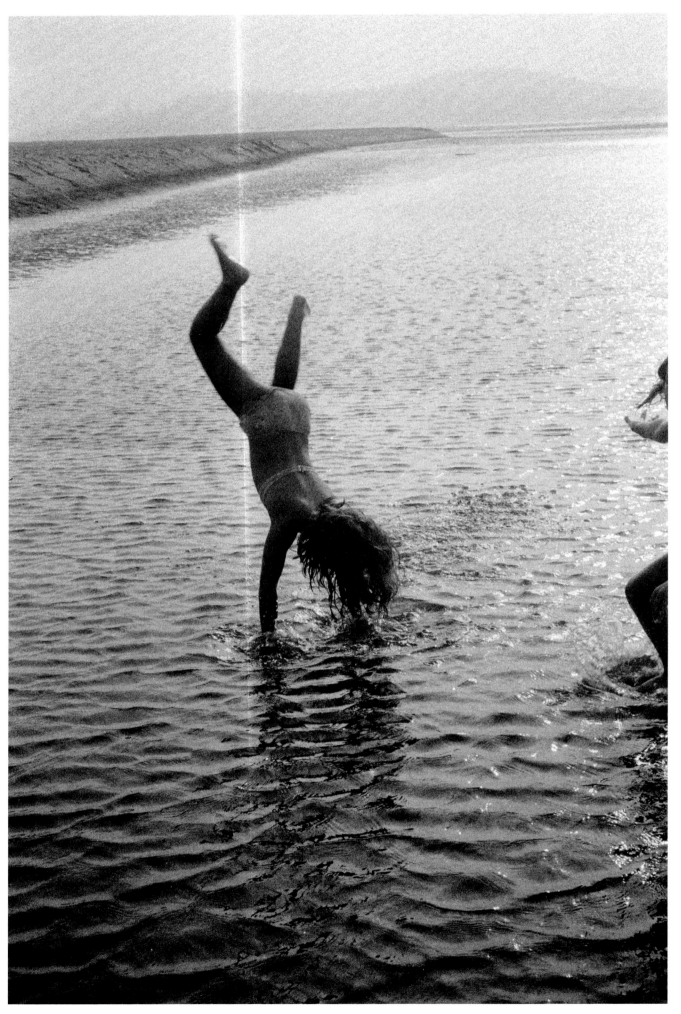

1975 Maine
At seven, Jenna does a cartwheel on Popham Beach.

2015 Tucson, Arizona
My daughter Jenna and her beau, Walid, visit me at the Arizona Inn.

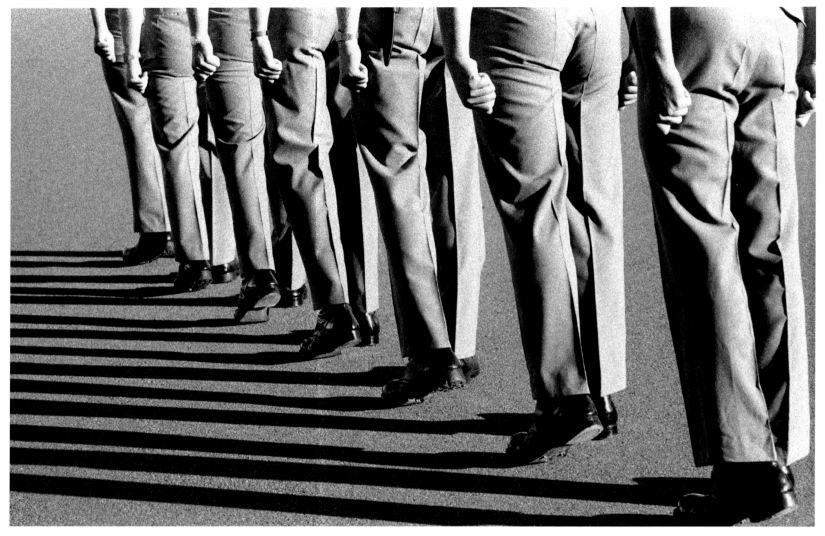

1981 Canberra
At Australia's Royal Military College, Duntroon, cadets execute the command "right face."

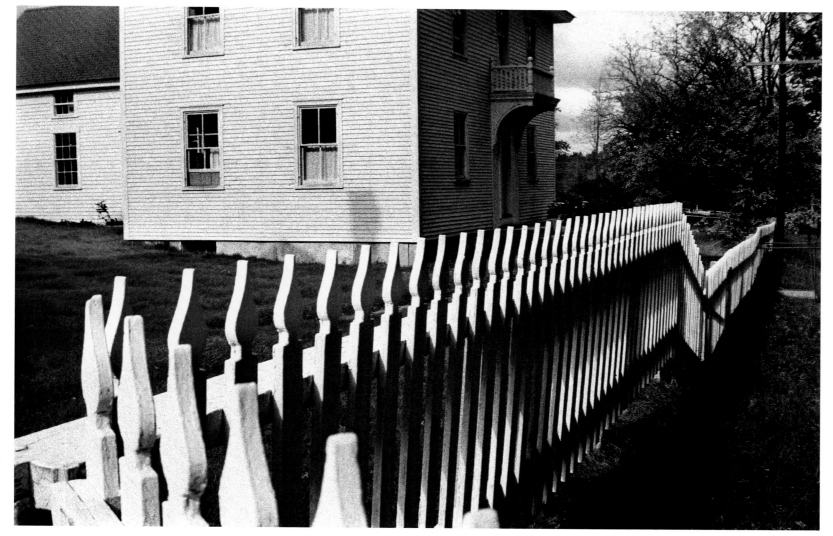

1966 Sabbathday Lake, Maine
Twelve remaining Shaker sisters keep the dwindling Shaker community running.

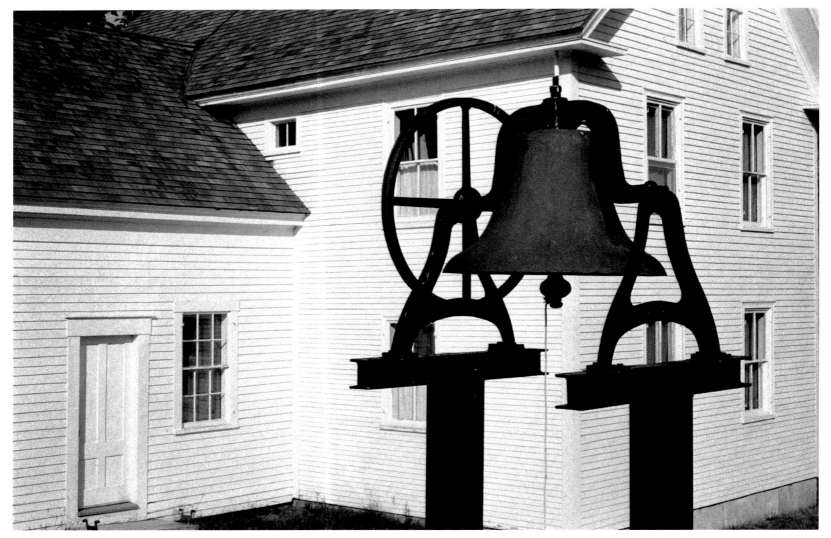

1995 Sabbathday Lake
When the Shakers closed their community at Alfred, Maine, in 1931,
the bell was moved downstate to Sabbathday Lake.

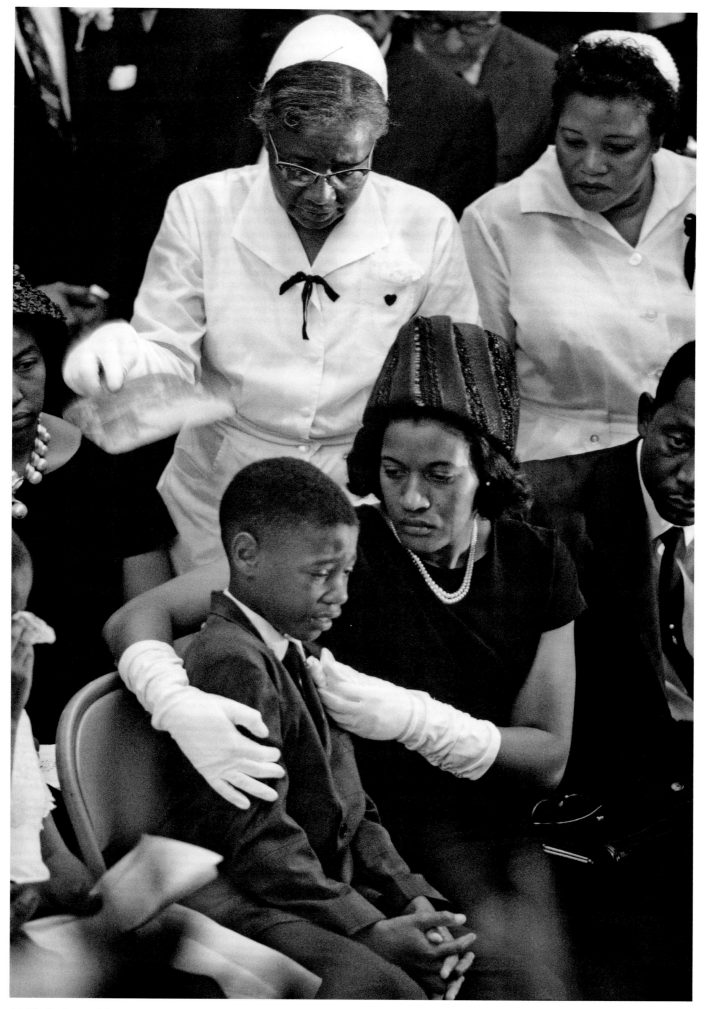

1963 Jackson, Mississippi
Medgar Evers, thirty-seven-year-old field secretary of the NAACP, was ambushed, shot dead in his driveway.
His widow, Myrlie, comforts their son, Darrell Kenyatta, at his funeral.

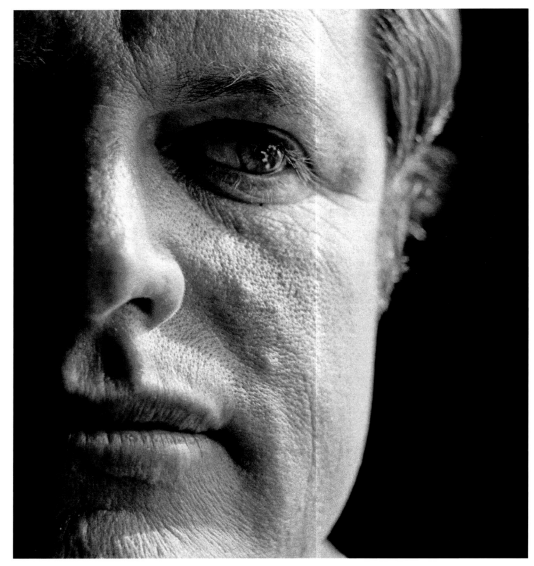

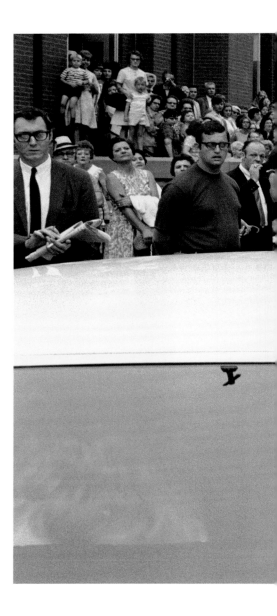

1969 Washington, D.C.
Many consider Edward Kennedy to be the heir-apparent to the presidency
in June, a year after his brother Robert's assassination. He poses in his senate office.

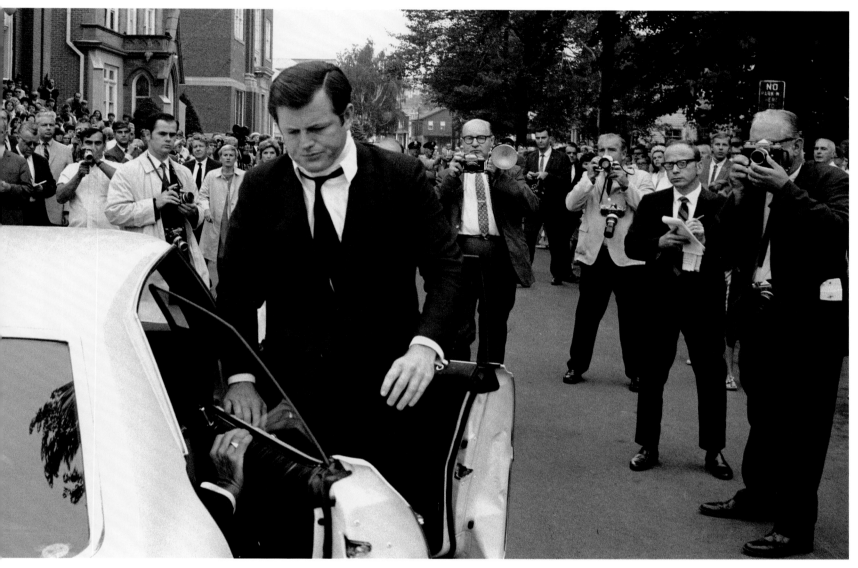

1969 Plymouth, Pennsylvania
Senator Edward Kennedy's car runs off a bridge late in the evening of July 18th. Mary Jo Kopechne
dies in the car. There are many questions, but the senator has been incommunicado. He is first
seen in public as he arrives for Ms. Kopechne's funeral four days later.

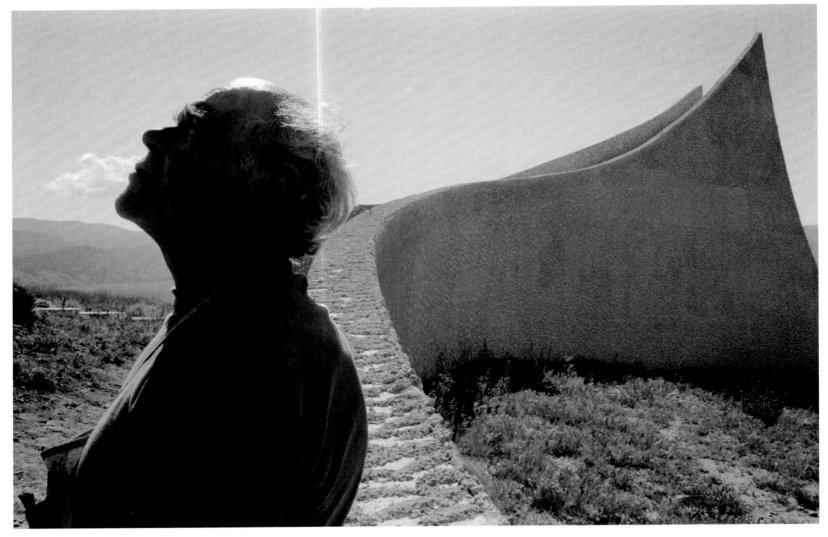

1972 Eagle Nest, New Mexico
Builder Victor Westphall has constructed a chapel in memory of
his son David, a Marine lieutenant killed four years earlier in Vietnam.

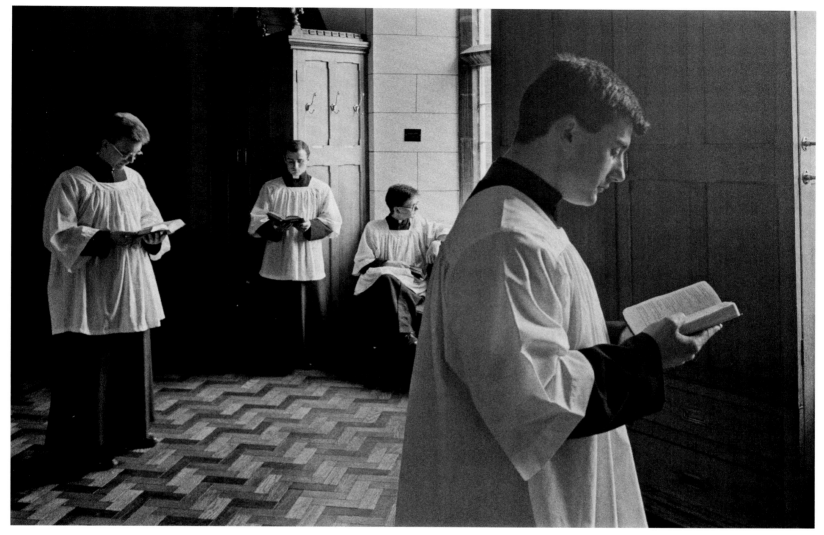

1991 Maynooth, Ireland
Novices wait in the vestry to help priests dress to celebrate mass.

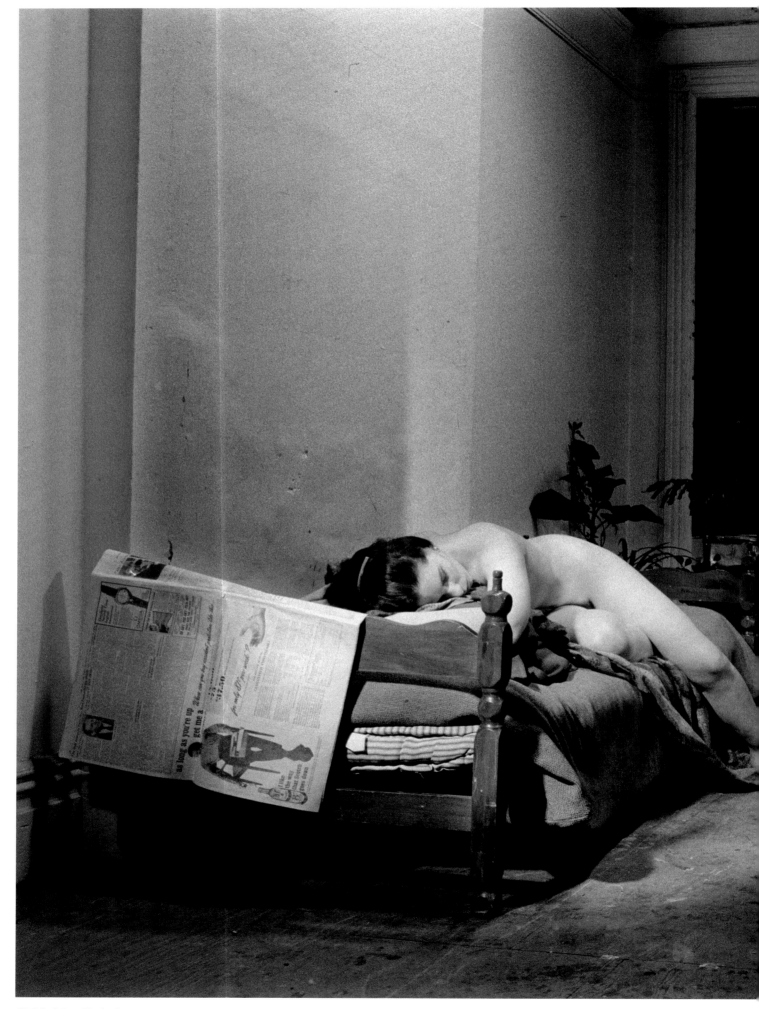

1966 New York City
Painter Philip Pearlstein works in a brownstone on Manhattan's Upper West Side.

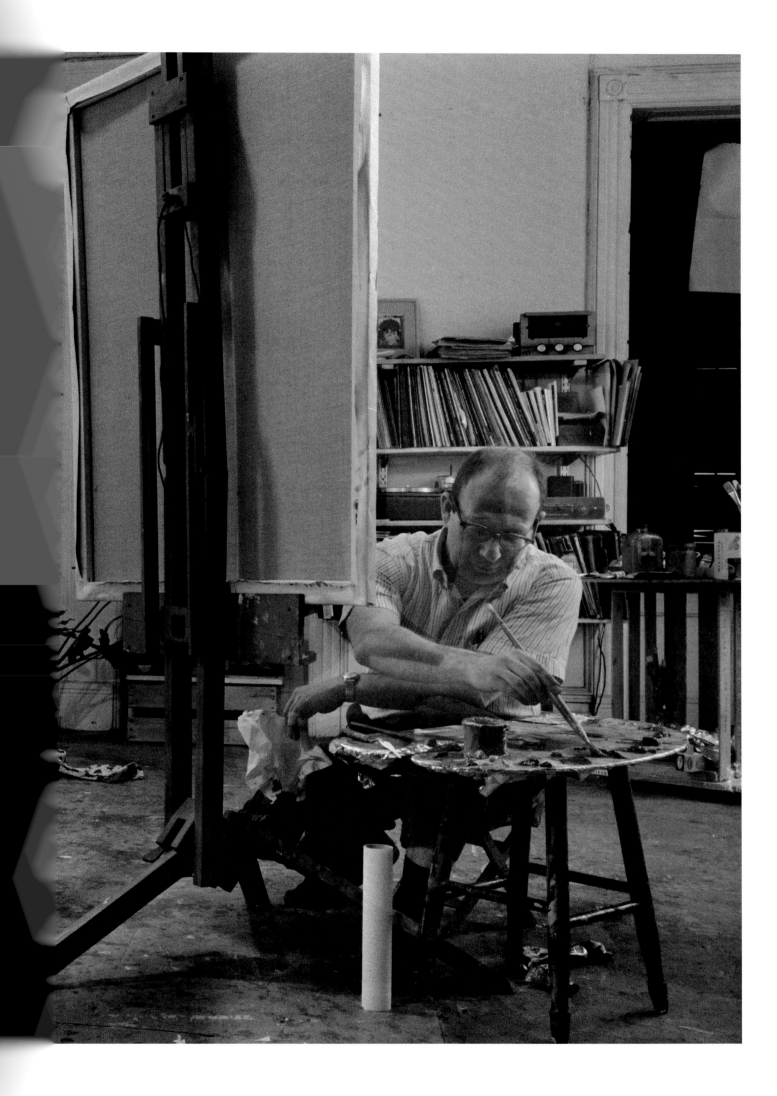

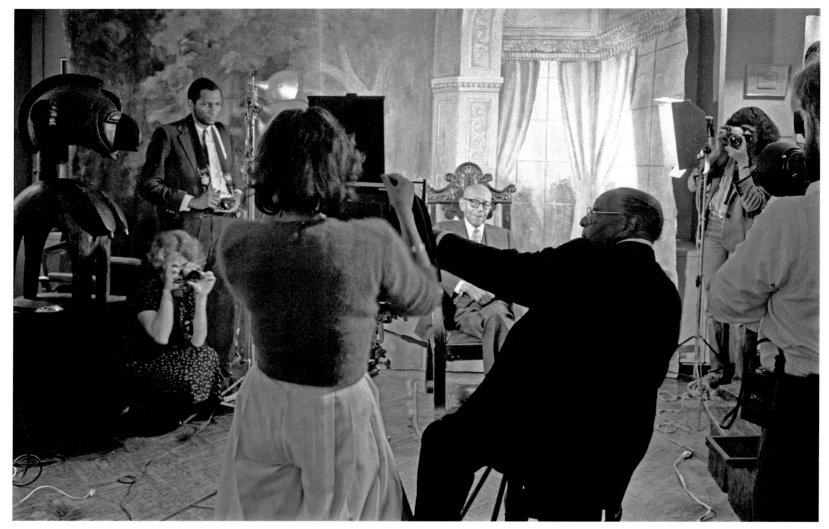

1981 New York City
James Van Der Zee, ninety-five, photographs composer Eubie Blake, ninety-eight, in a Madison Avenue art gallery.

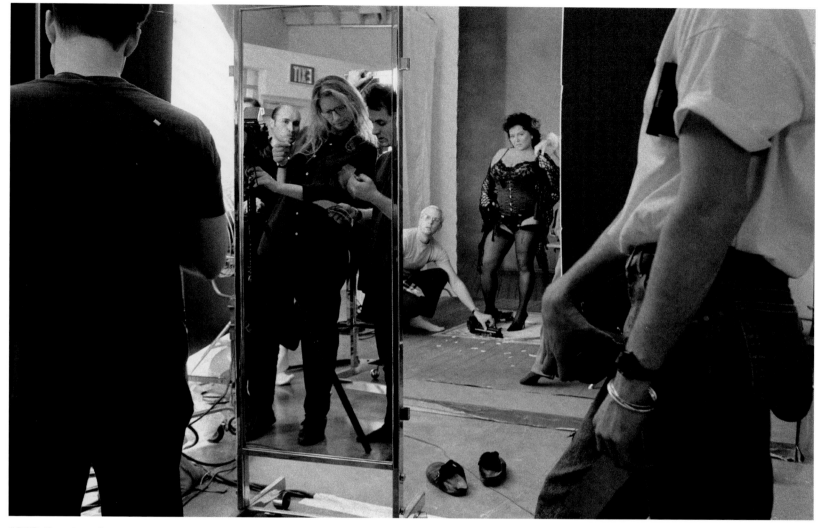

1993 Los Angeles
Posing for a *Vanity Fair* magazine cover, comedian Roseanne Barr waits
as Annie Leibovitz checks a Polaroid test picture that develops itself in seconds.

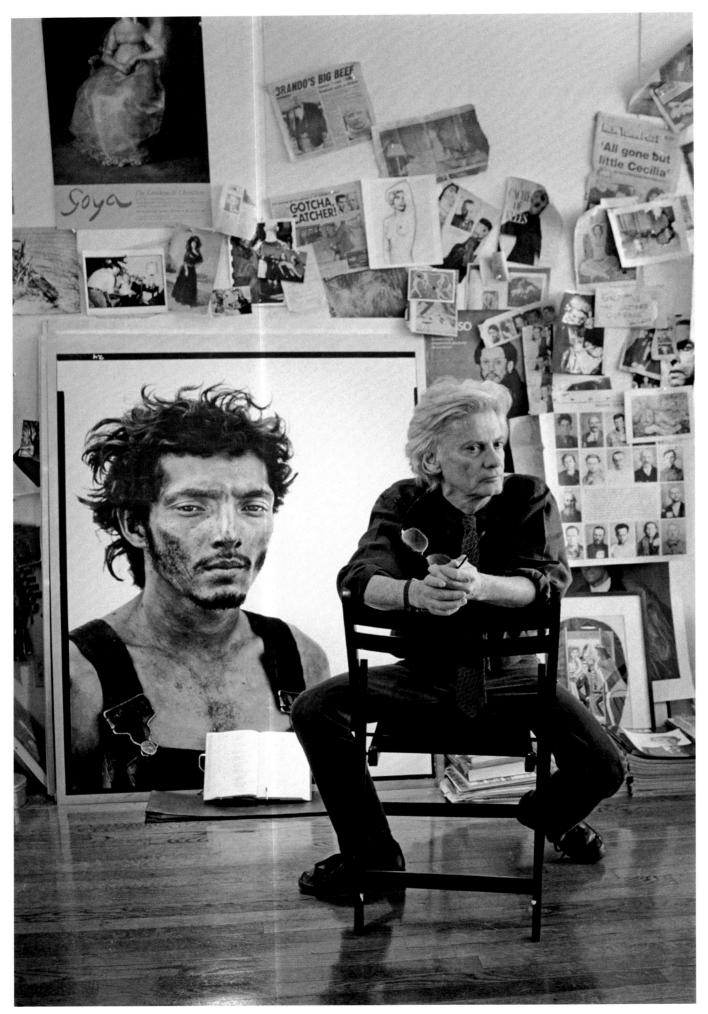

1994 New York City
Richard Avedon sits in his studio before a wall of miscellaneous
clippings and his portrait of oil field worker Roberto Lopez.

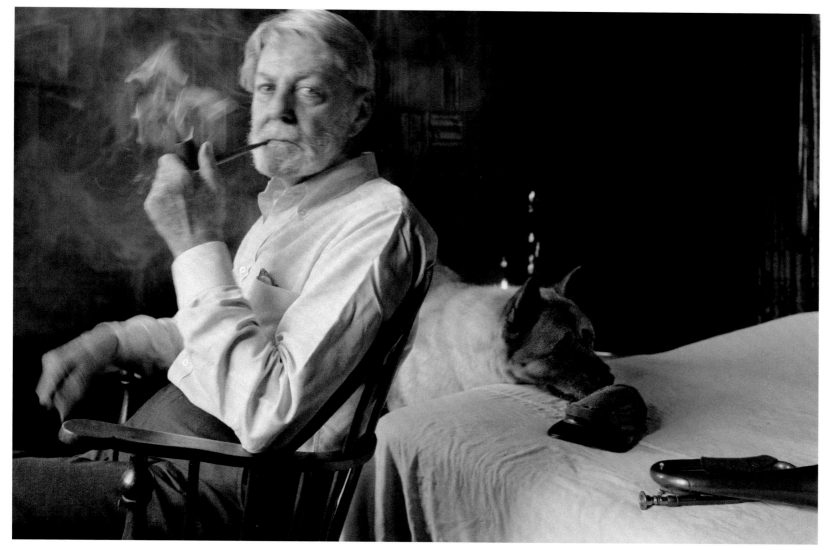

1990 Memphis, Tennessee
Historian Shelby Foote has become widely known for appearances
as a narrator in a Ken Burns television documentary on the Civil War.

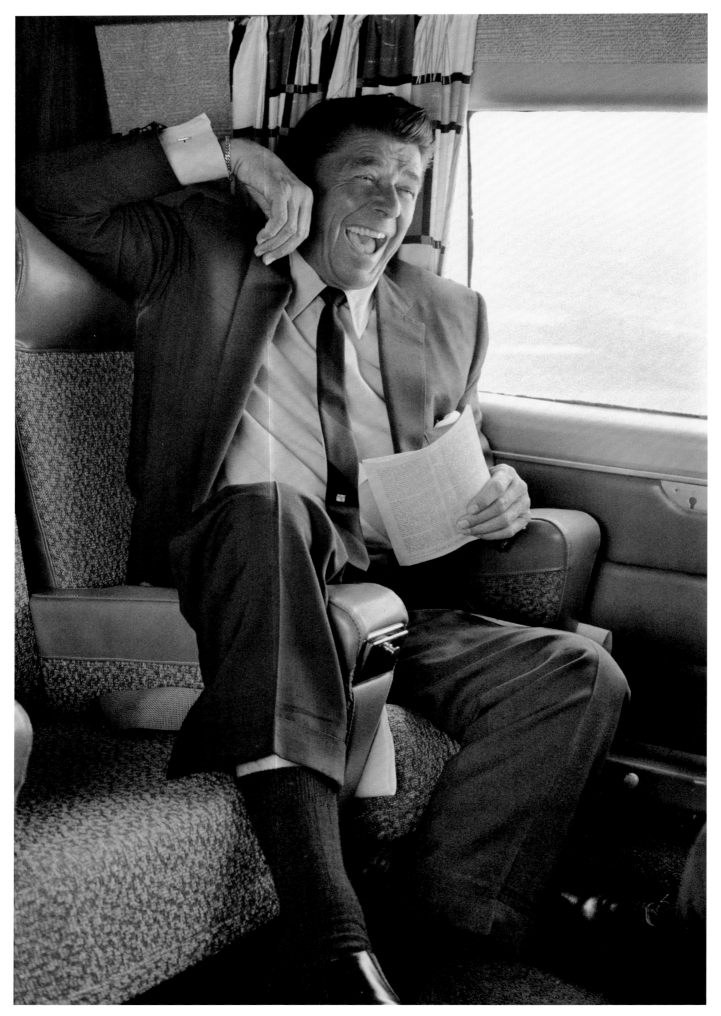

1966 California
Actor Ronald Reagan swaps jokes with his advisors in the back of a DC-3
airplane ten days before the Republican gubernatorial primary in California.

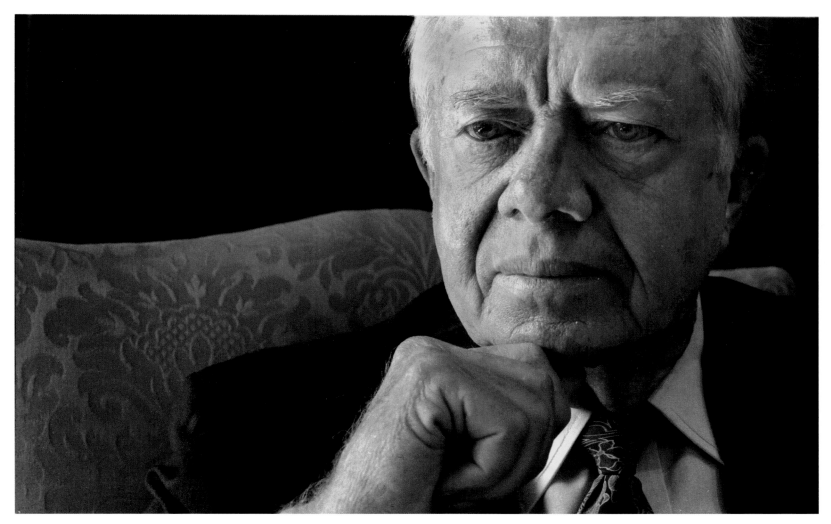

1994 Atlanta, Georgia
Jimmy Carter, a thoughtful ex-president, seems to have more on his mind than having his picture taken.

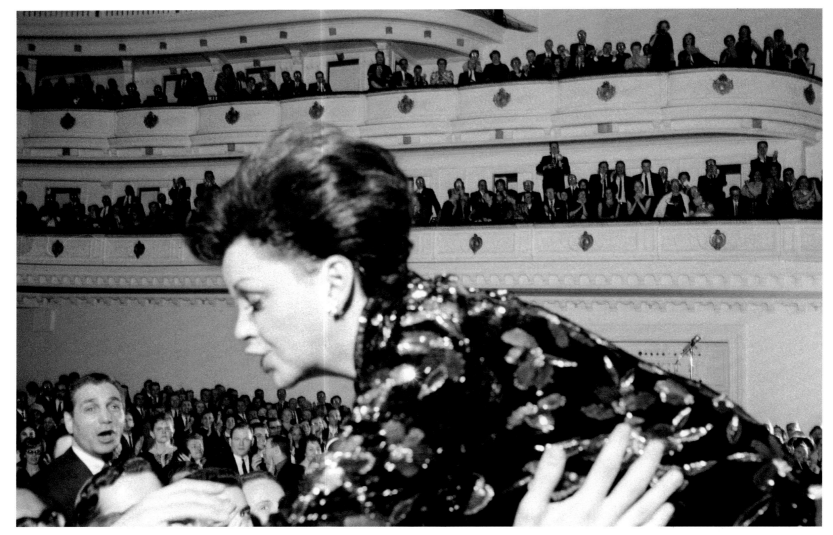

1961 New York City
Singer Judy Garland greets fans at the end of her concert in Carnegie Hall.

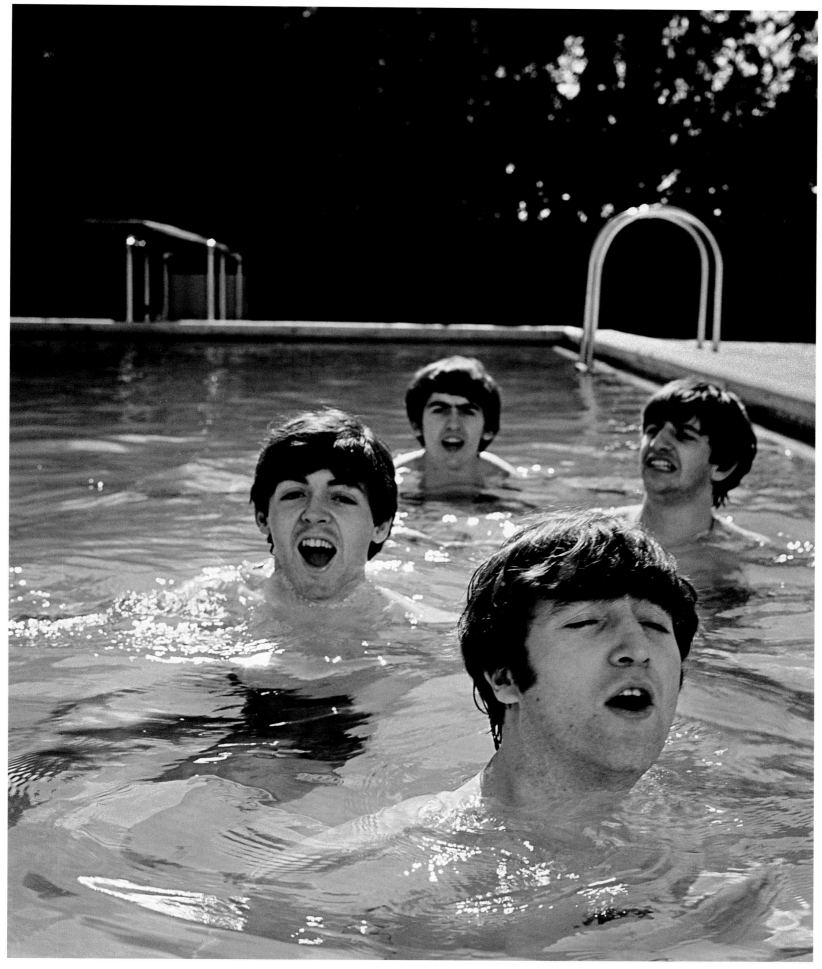

1964 Miami Beach
Four boys from Liverpool sing in an unheated pool during a cold snap at the end of their first week in America.

1989 Chicago, Illinois
Sara Paretsky centers her popular crime novels on a female private investigator.

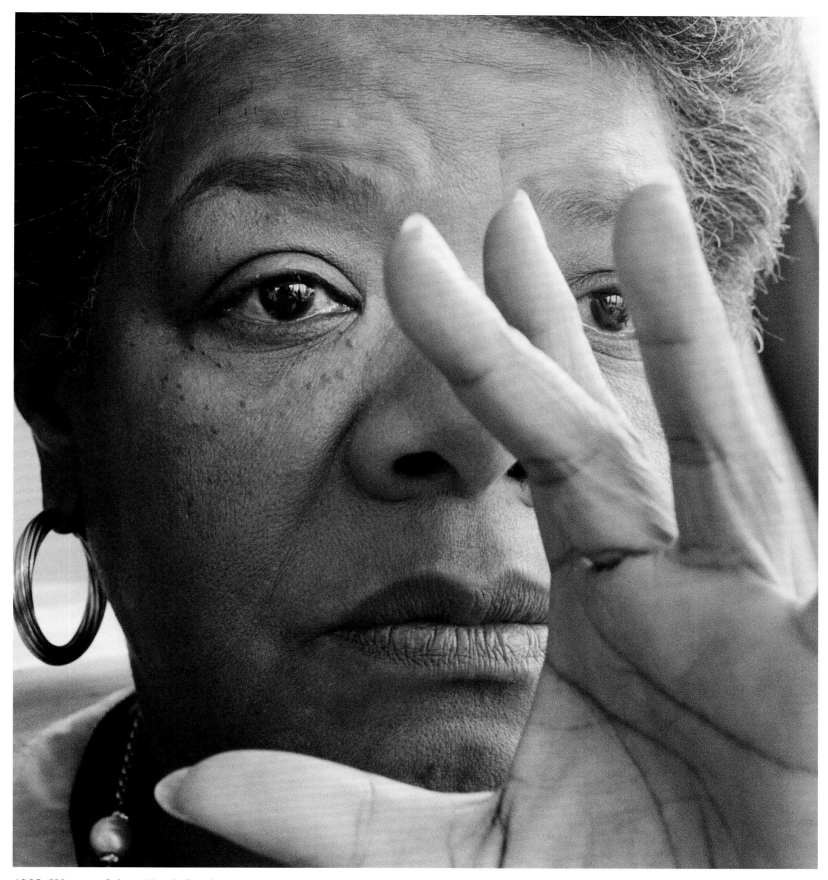

1992 Winston-Salem, North Carolina
Poet Maya Angelou will have a role in President Clinton's first inauguration four weeks off. She says,
"I am still mulling over how to say different things . . . I'm doing that this moment while you're taking pictures."

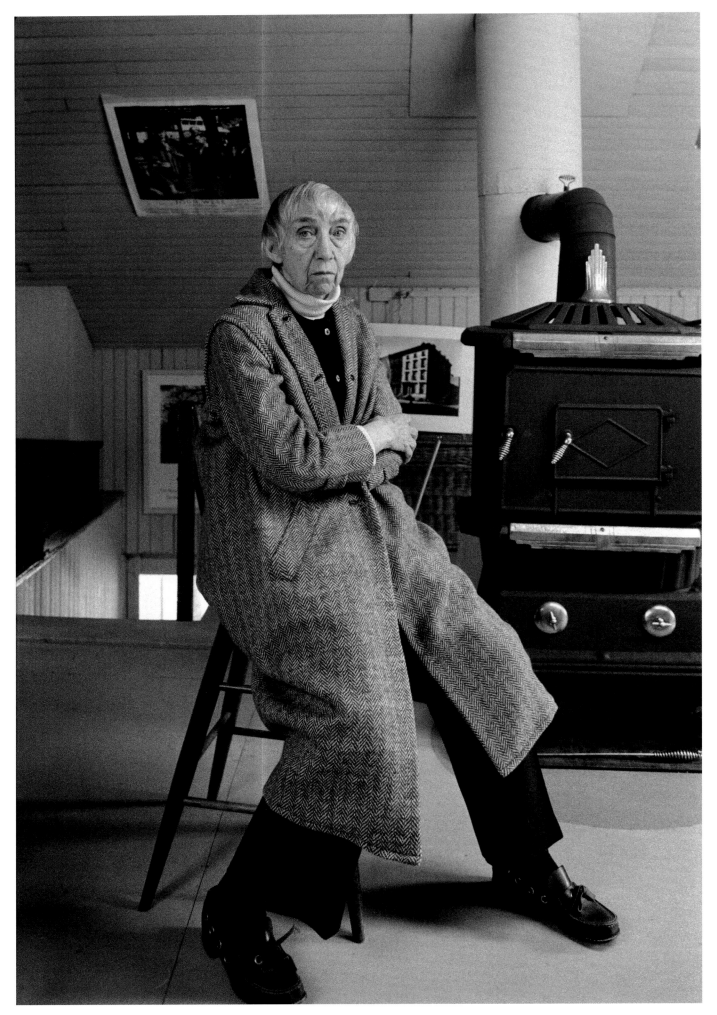

1981 Abbot, Maine
On a chilly September morning, photographer Berenice Abbott does not light the stove in her studio.

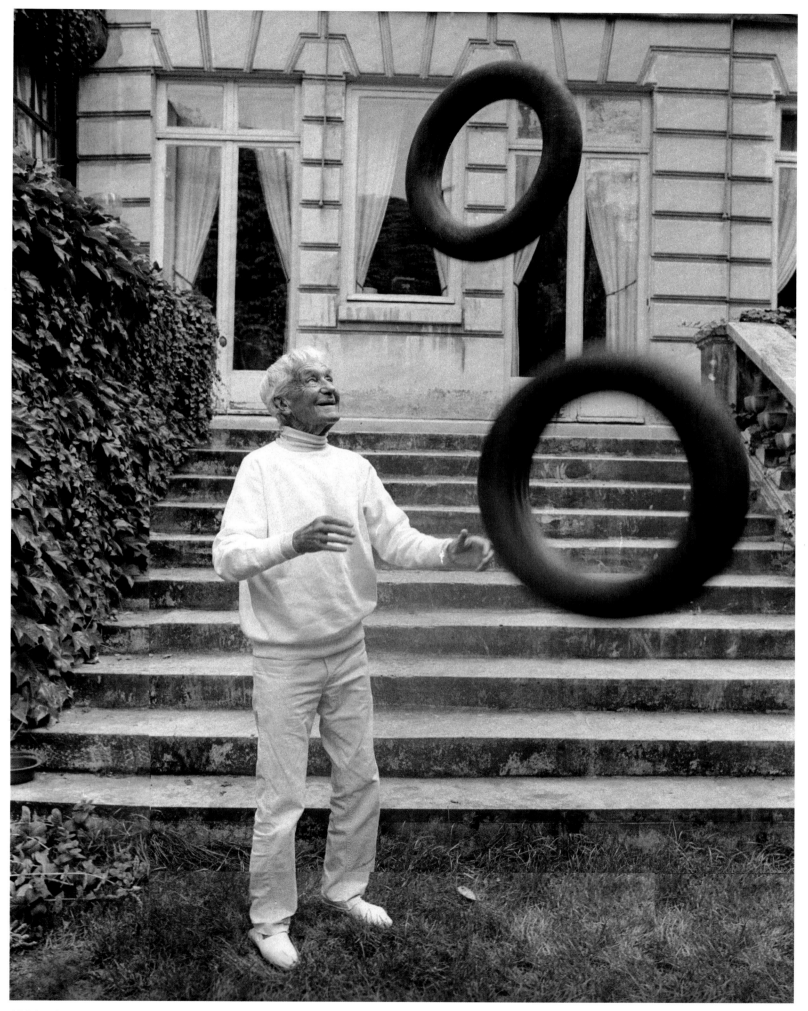

1981 40 Rue Cortambert, Paris
Jacques Henri Lartigue, eighty-seven, a camera prodigy, juggles inner tubes at his boyhood home.
At age eleven, he pictured his cousin Bichonnade leaping off these terrace steps.

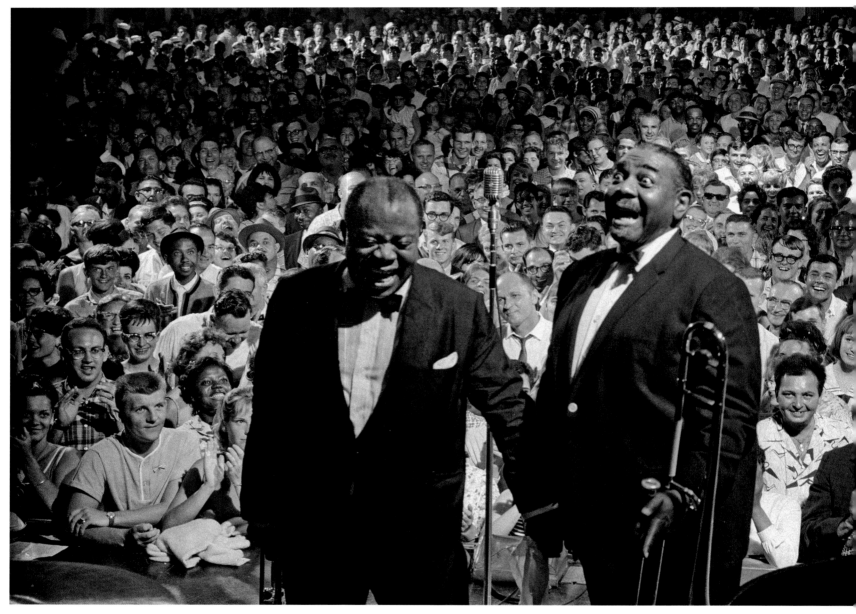

1965 Atlantic City, New Jersey
Louis Armstrong turns his back on his enthralled audience while singing
Hello Dolly! on the Steel Pier in Atlantic City beside trombonist Tyree Glenn.

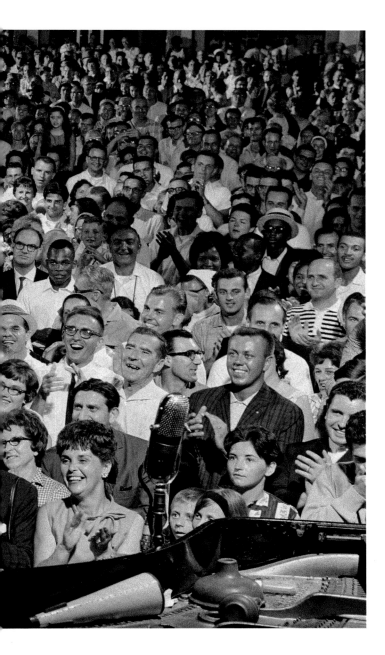

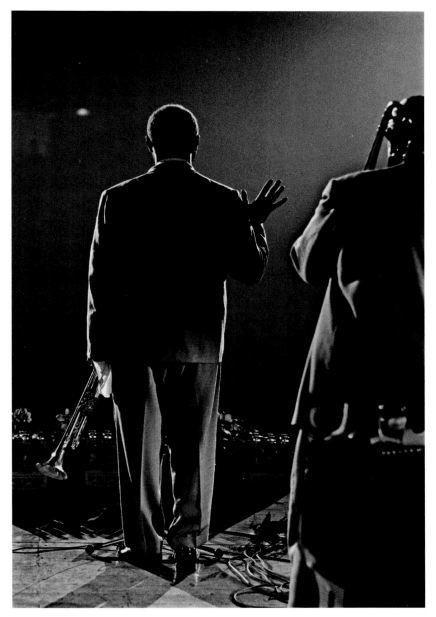

1965 Munich
Sixty-five-year-old Armstrong holds his trumpet
still and waves goodnight to his audience in Munich.

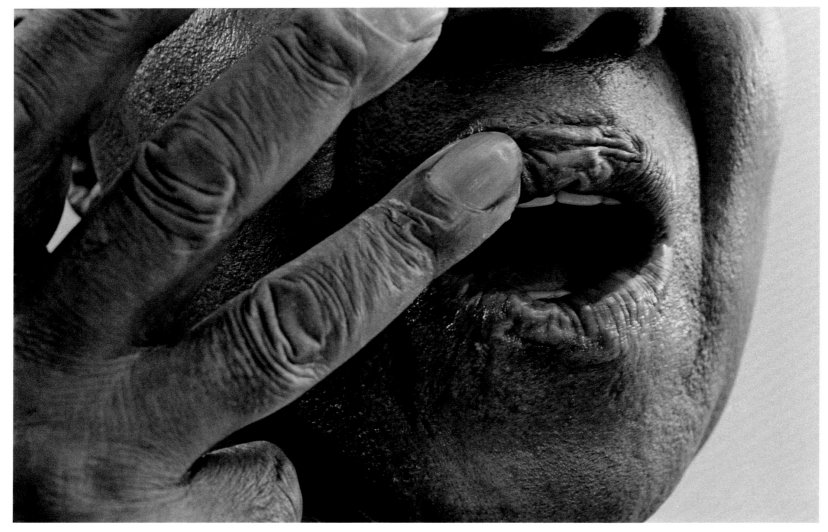

1965 Las Vegas, Nevada
Louis Armstrong puts salve on his lips after a performance in Las Vegas.

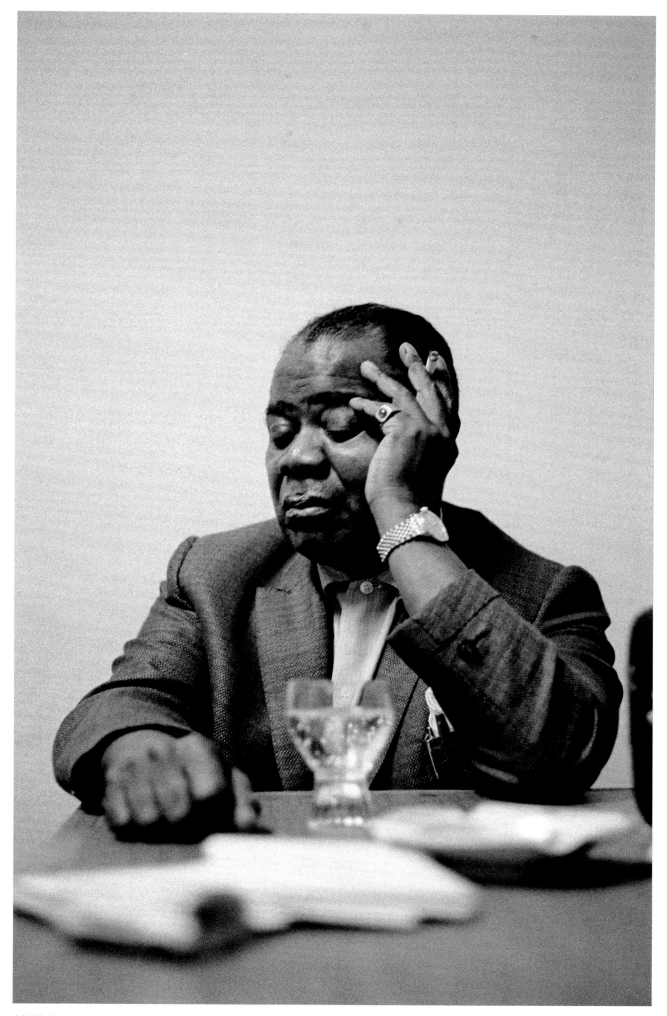

1965 Essen, Germany
Armstrong decompresses after a performance in Essen, Germany.
He faces a seven-hour bus ride to Munich for another one-night stand.

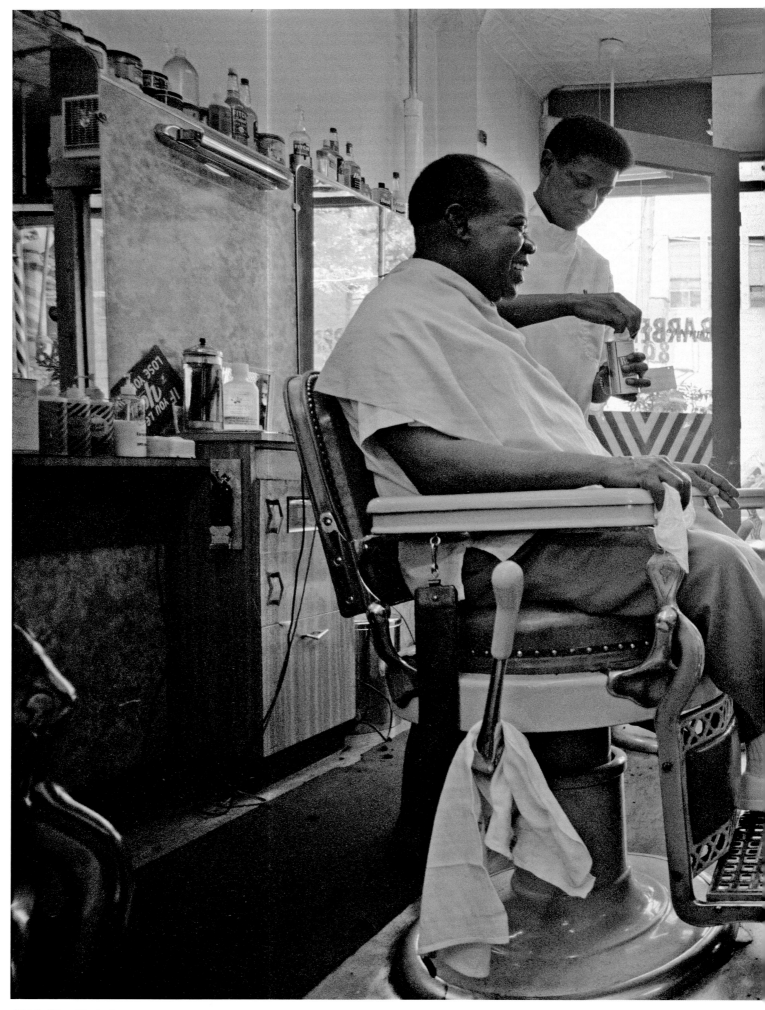

1965 New York City
At his neighborhood barbershop in Queens, Louis Armstrong gets a beer and a haircut.

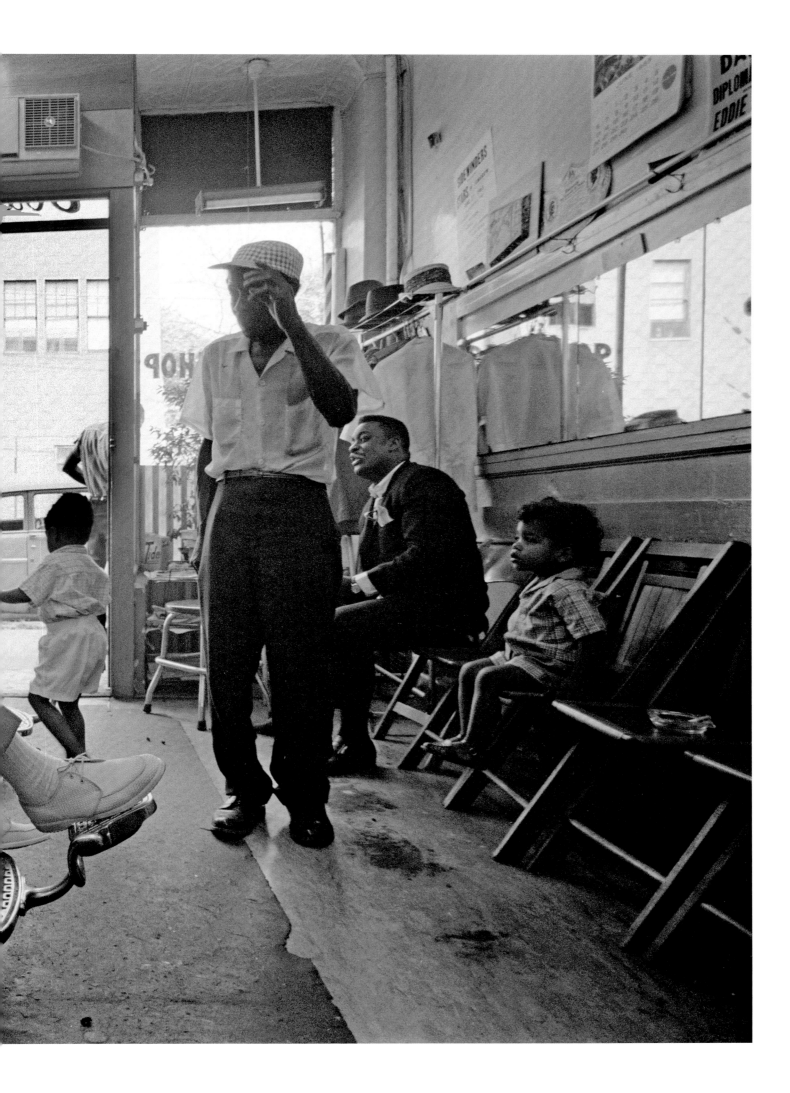

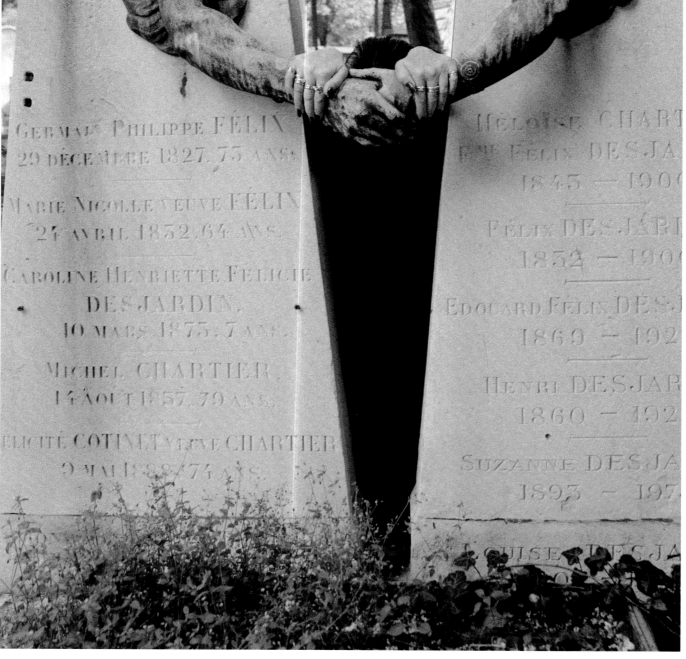

1991 Paris
Jill Gill, a painter, finds the Felix family's memorial handy.

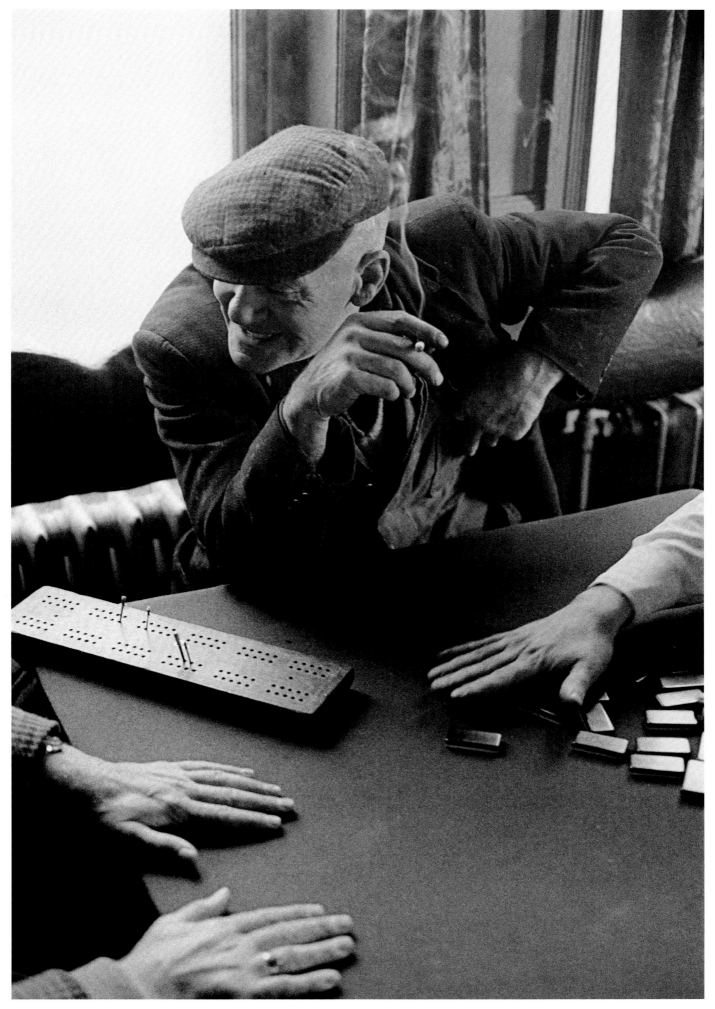

1968 London
The game of choice at a workers' club in London is dominos.

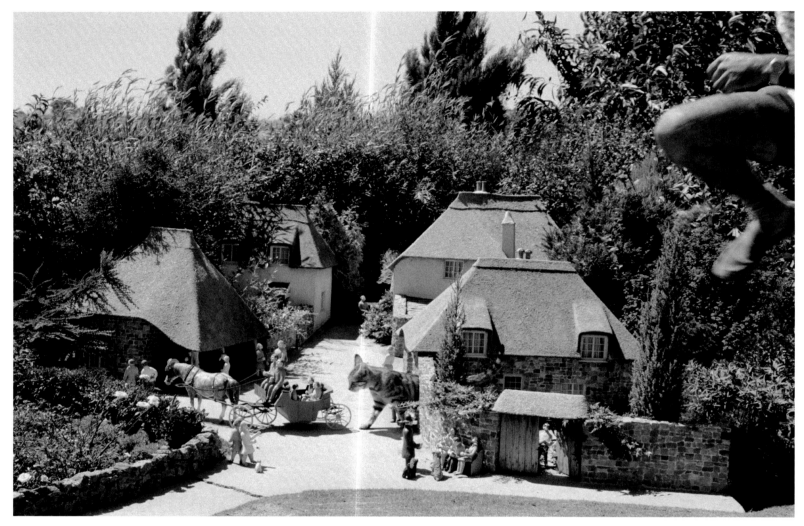

1981 Canberra
The owner of a miniature village hops back out of town after delivering a kitten to the town square.

1987 New York City
Cabaret singer Andrea Marcovicci says her mother, a nightclub performer, sang torch songs at the breakfast table.

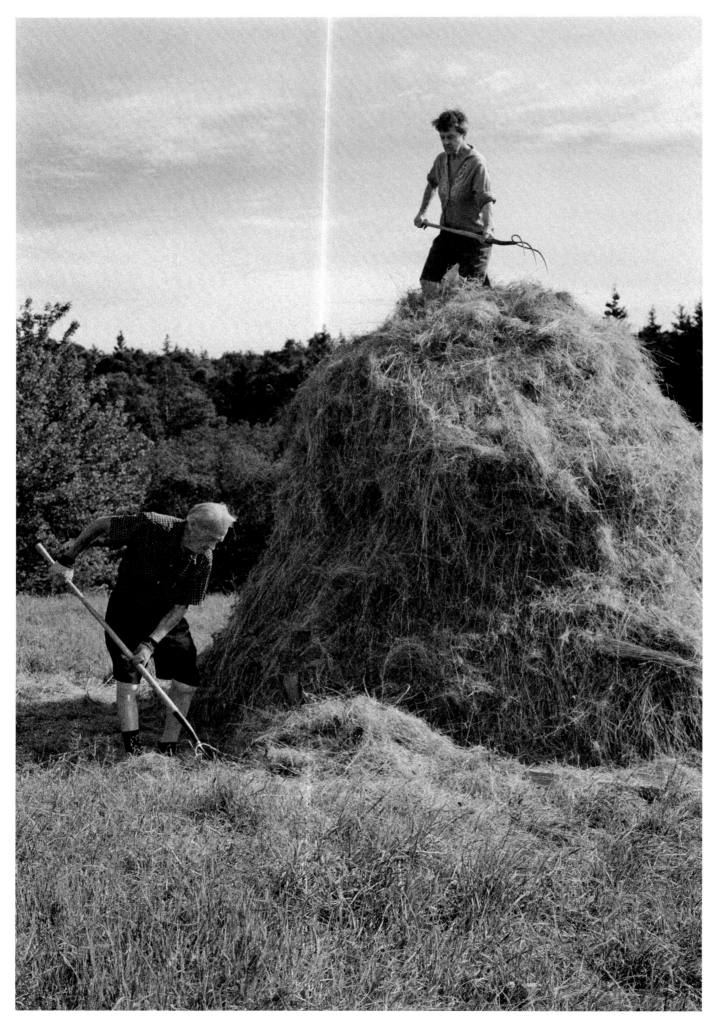

1976 Harborside, Maine
Ninety-three-year-old Scott Nearing, a leftist with an MBA from Wharton,
quit the economy thirty years ago and sought a self-sufficient life.

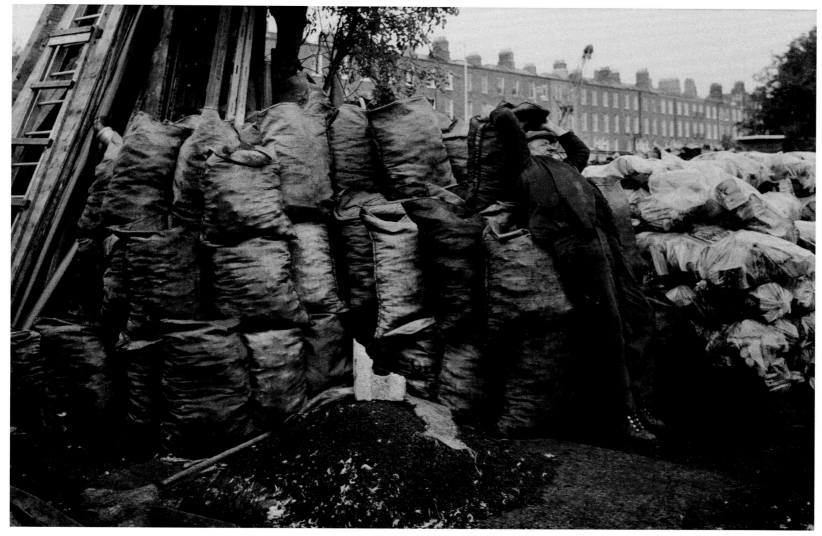

1987 Dublin
Paddy Dunne sells anthracite coal, firewood, turf, and compressed dust pellets.

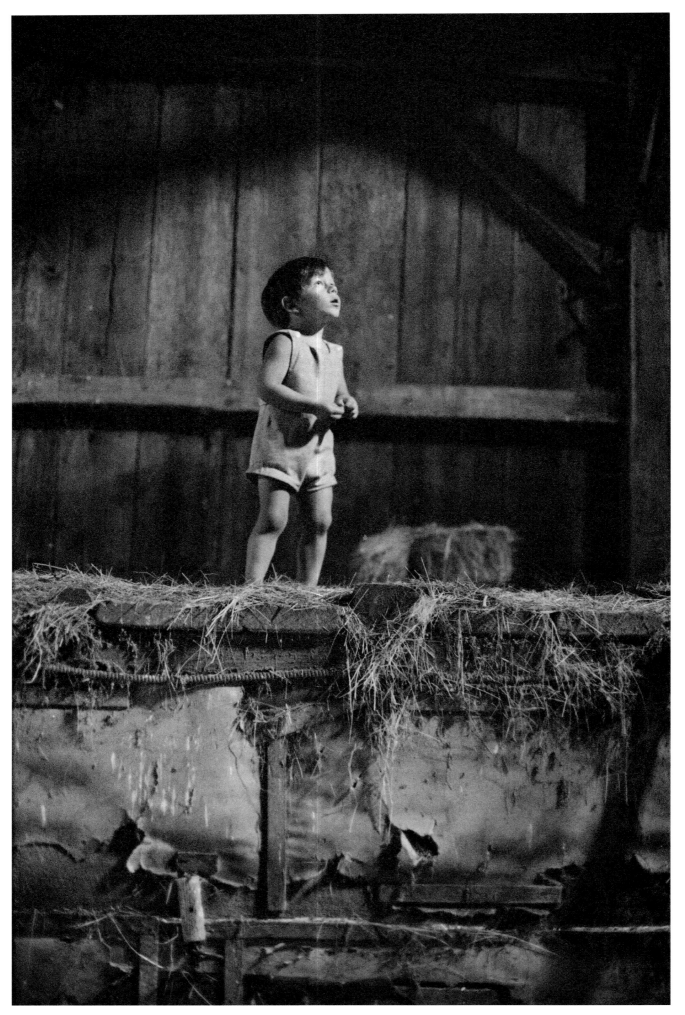

1967 Woolwich
Three-year-old Charles watches swallows swoop among the rafters of our barn.

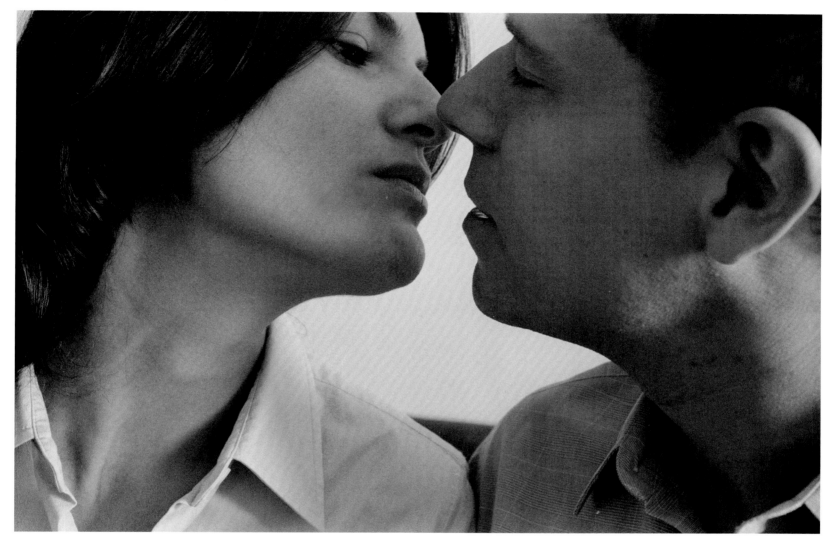

2006 New York City
Charles kisses his beloved Natasha.

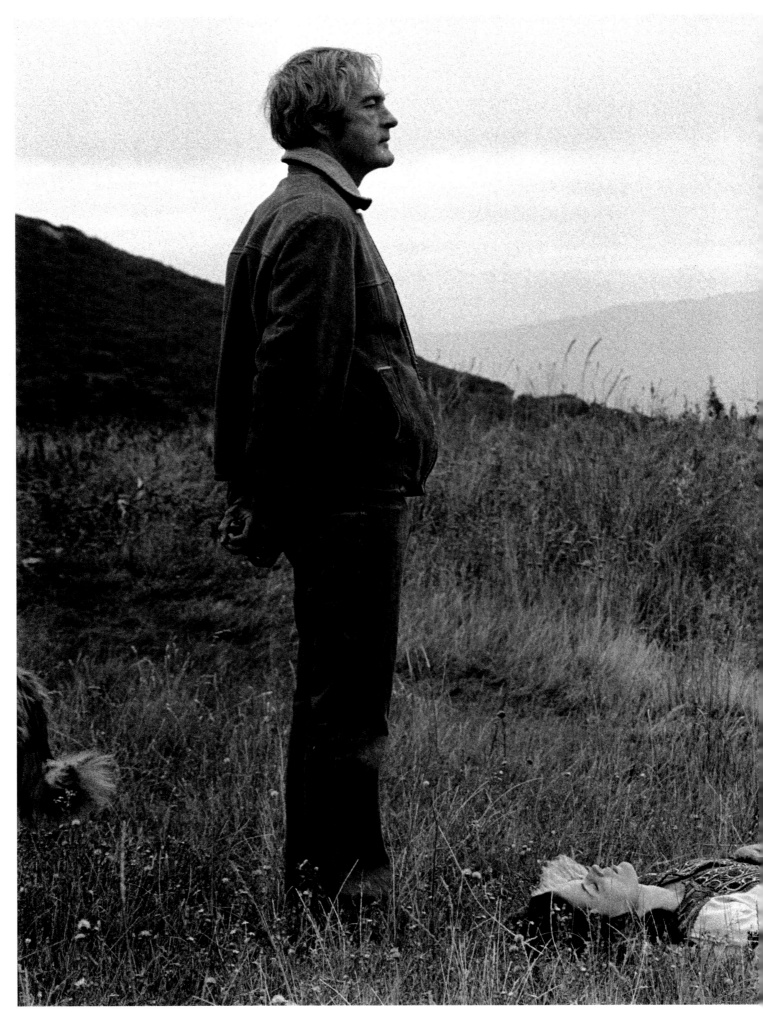

1969 California
Dr. Timothy Leary, forty-nine, believes in the personal use of psychedelic drugs and lives in a commune near Palm Springs with his wife, Rosemary. He is running for governor of California.

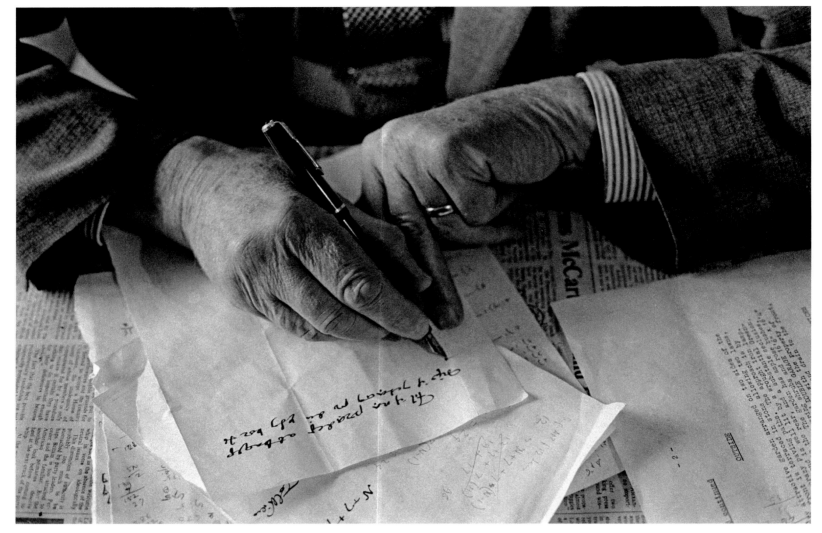

1968 Bournemouth, England
On vacation in Bournemouth, J. R. R. Tolkien rents a second room in the attic of the Miramar Hotel
and writes there on a battered card table. A professor of language at Oxford University, he has invented
one of his own. I ask him to write something in it. I trust he's doing so.

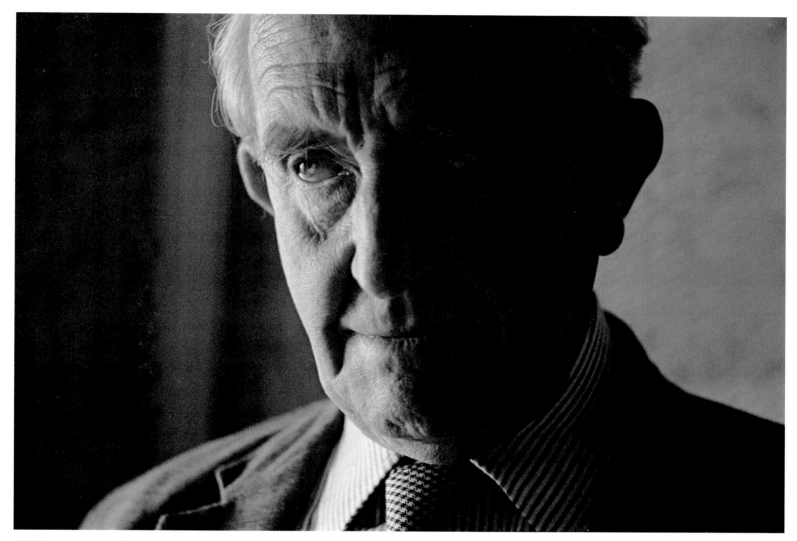

1968 Bournemouth
Tolkien is the author of *The Hobbit* and *The Lord of the Rings*.

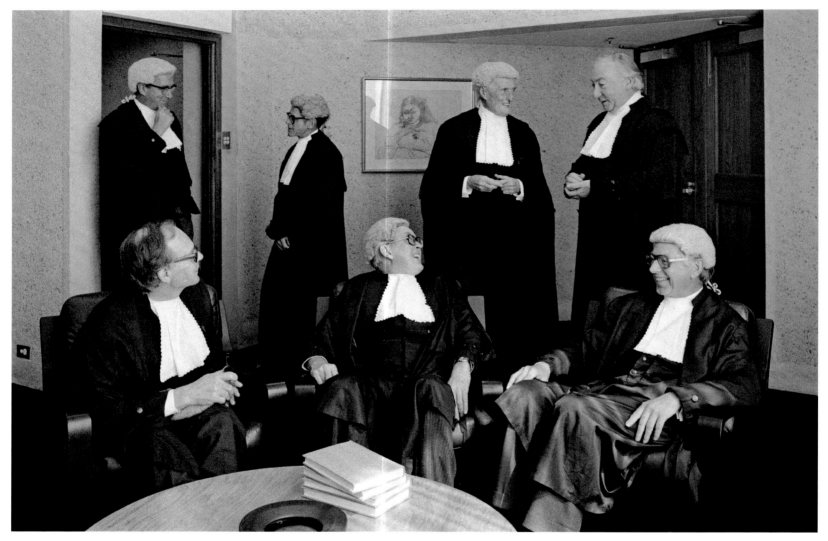

1981 Canberra
Justices of Australia's supreme court tease one another about being photographed.

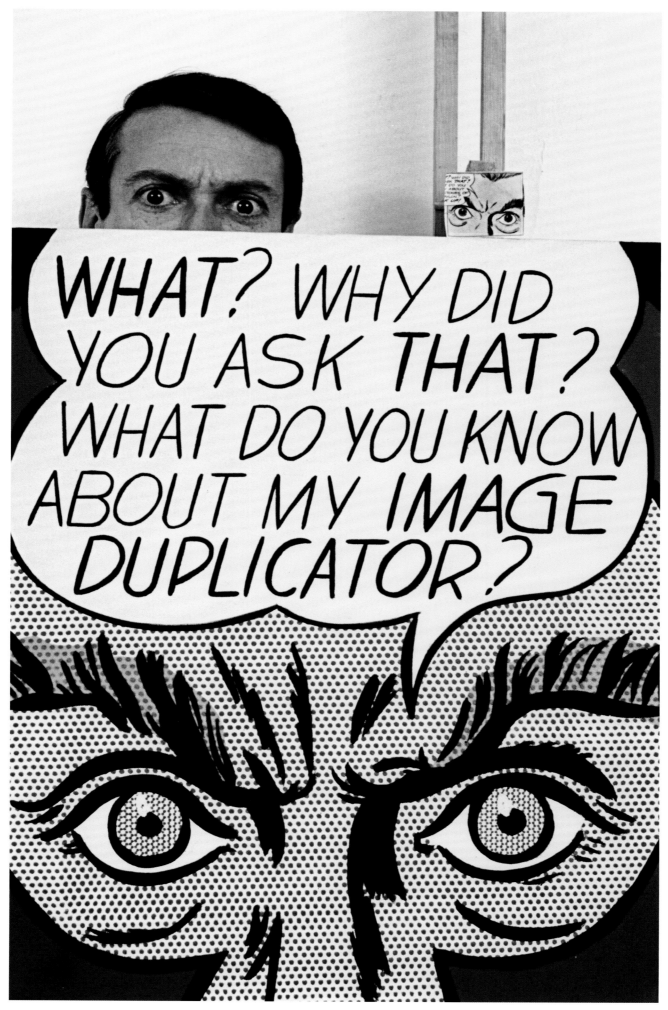

1963 New York City
Painter Roy Lichtenstein clowns behind his inspiration and his finished canvas.

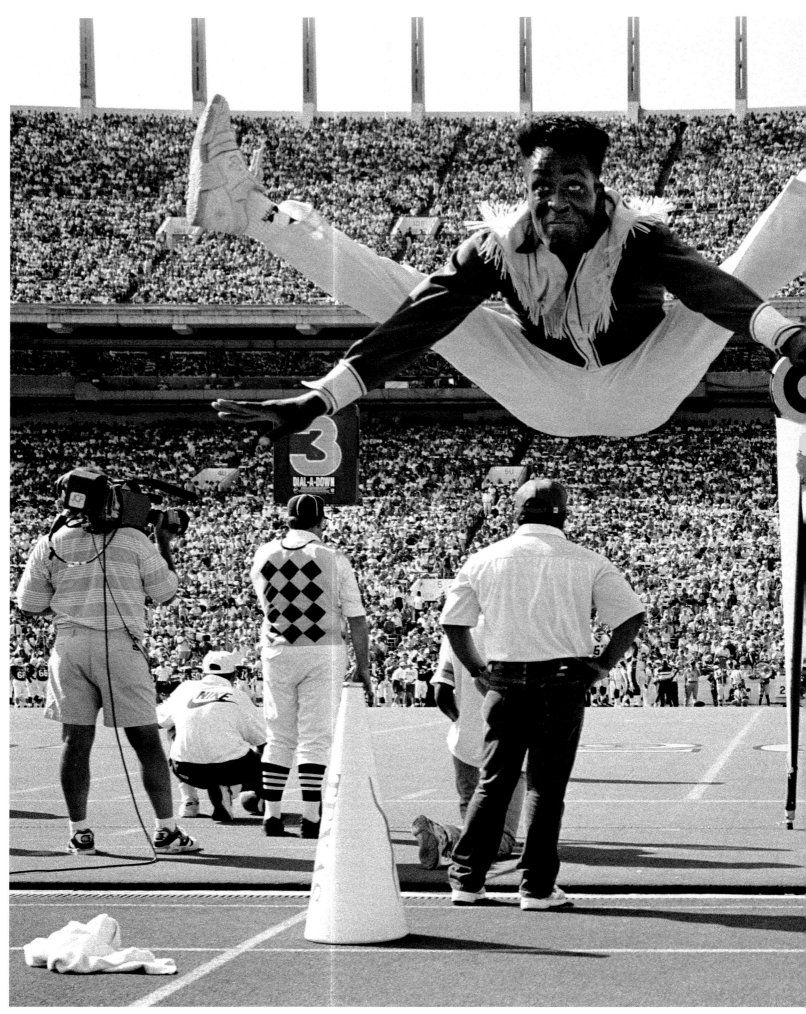

1992 Austin
Cheerleaders at the University of Texas rise to the occasion.

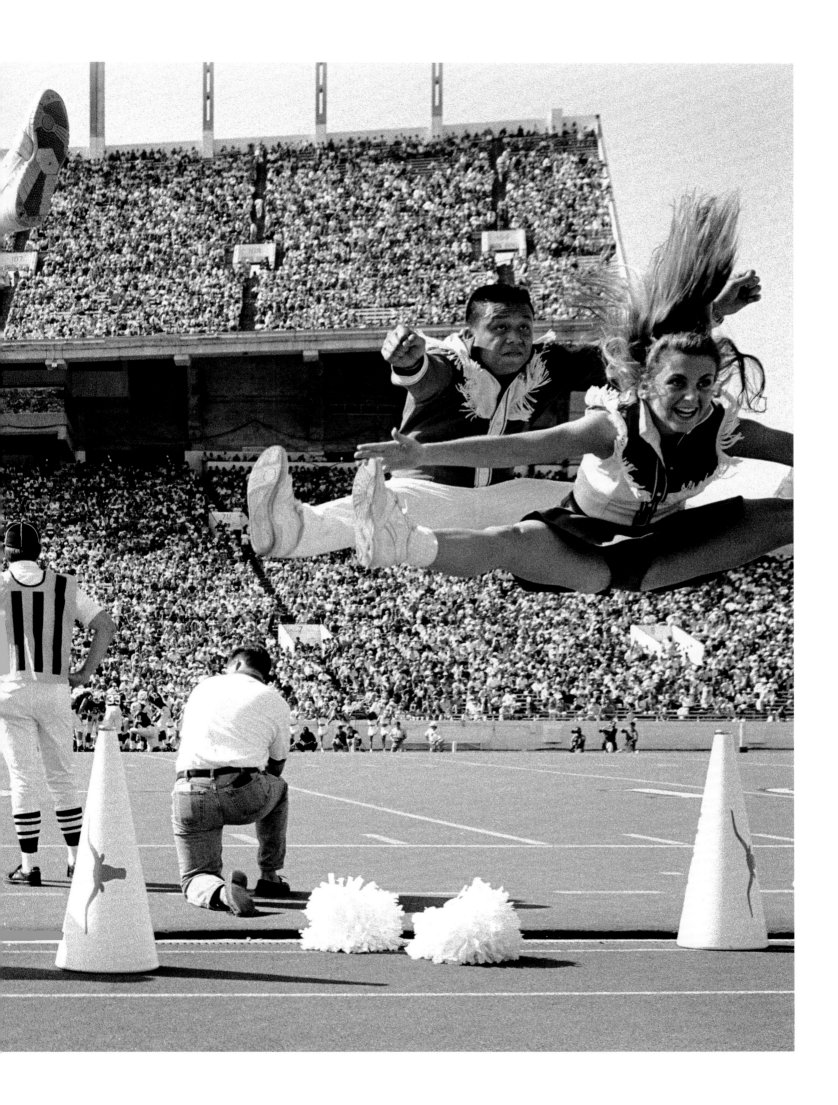

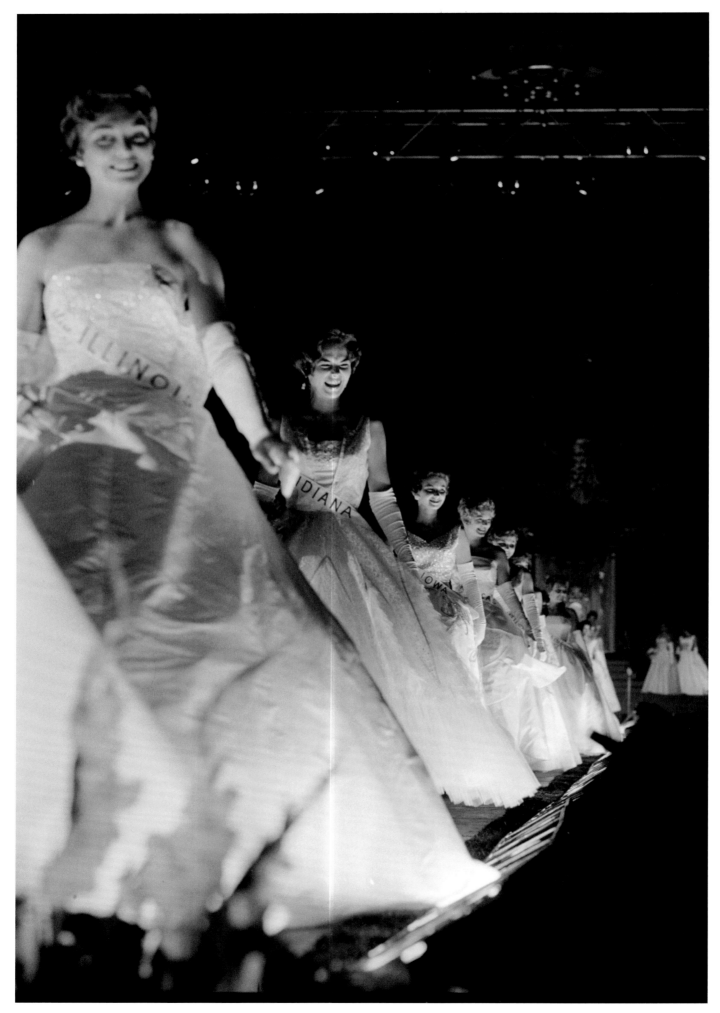

1961 Atlantic City
Contestants sweep onstage state-by-state.

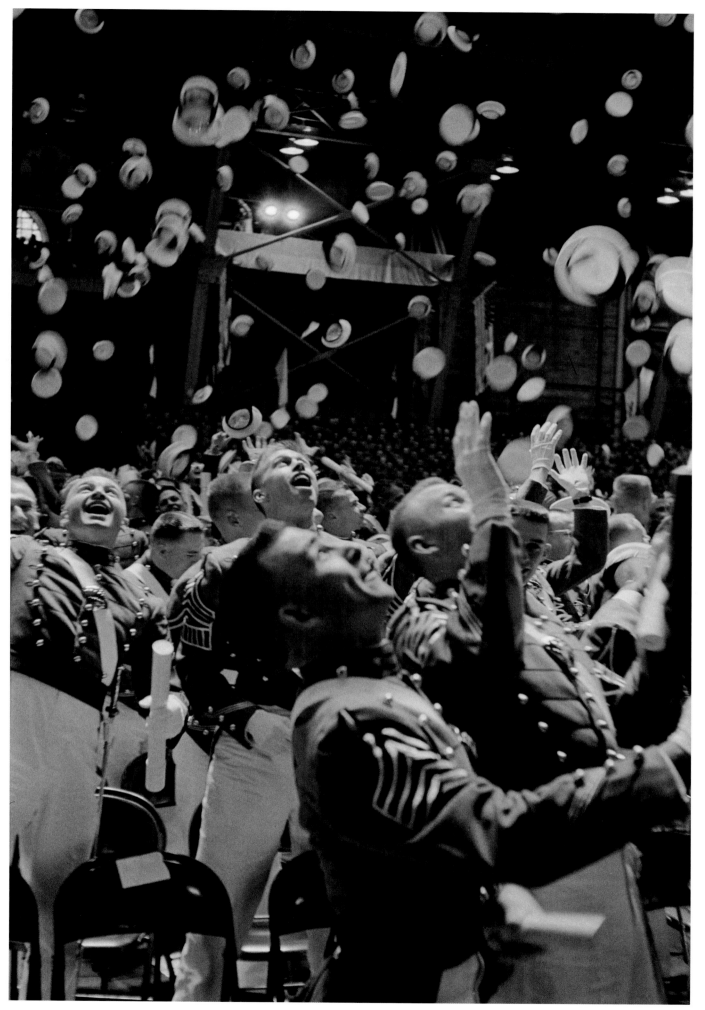

1961 West Point, New York
Cadet Captain John L. Kammerdiener (foreground) has the highest academic grades in a graduating class of 534.

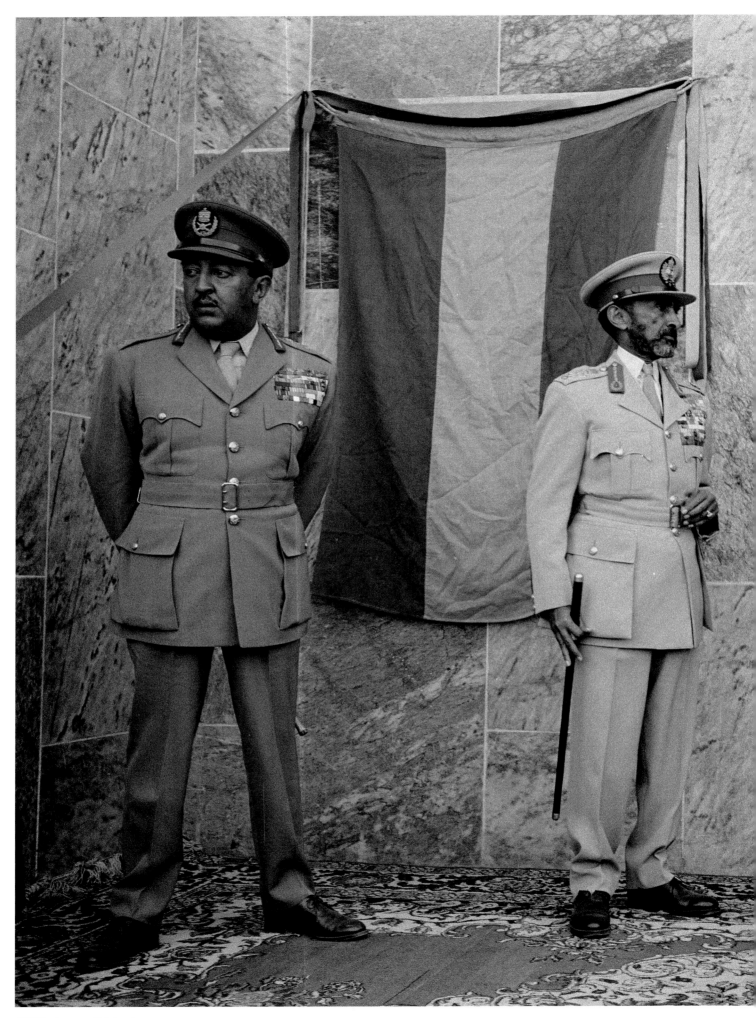

1965 Axum, Ethiopia
England's Queen Elizabeth II and Duke of Edinburgh wait with their hosts, Emperor Haile Selassie
of Ethiopia and his son, the Crown Prince, before they enter the New Cathedral of St. Mary of Zion.

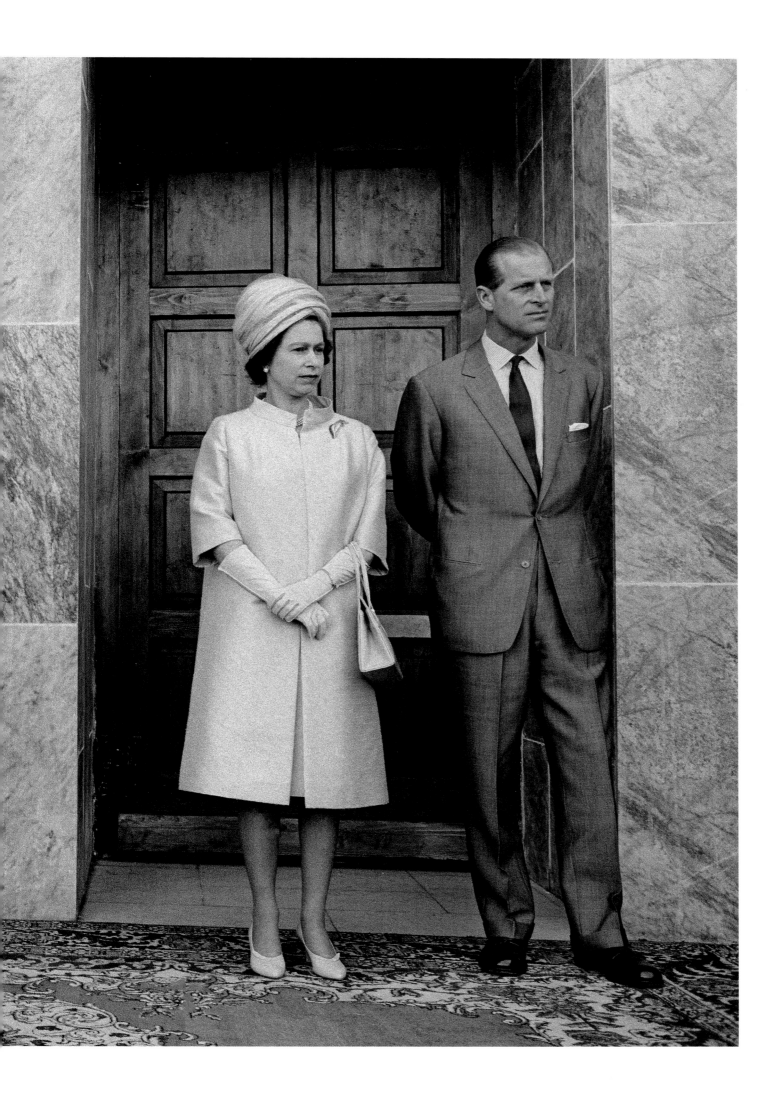

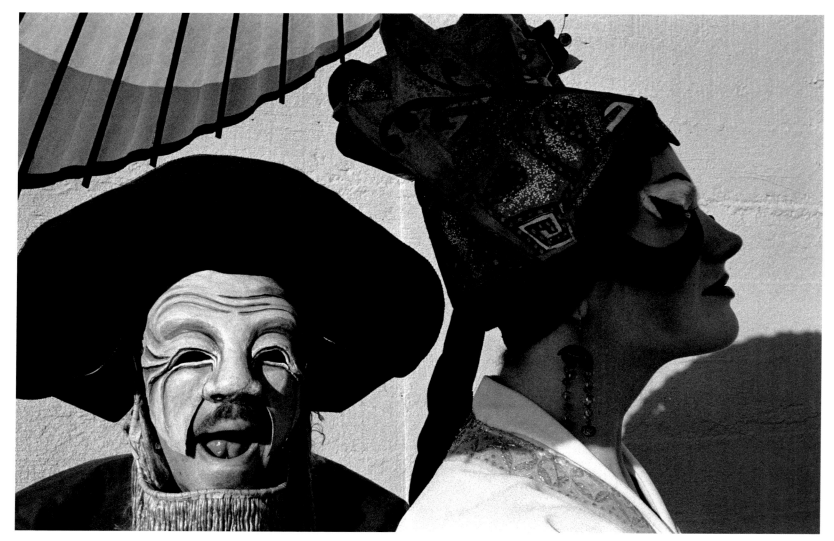

1969 San Francisco
Performers from the San Francisco Mime Troupe rehearse Bertolt Brecht's *Congress of Whitewashers.*

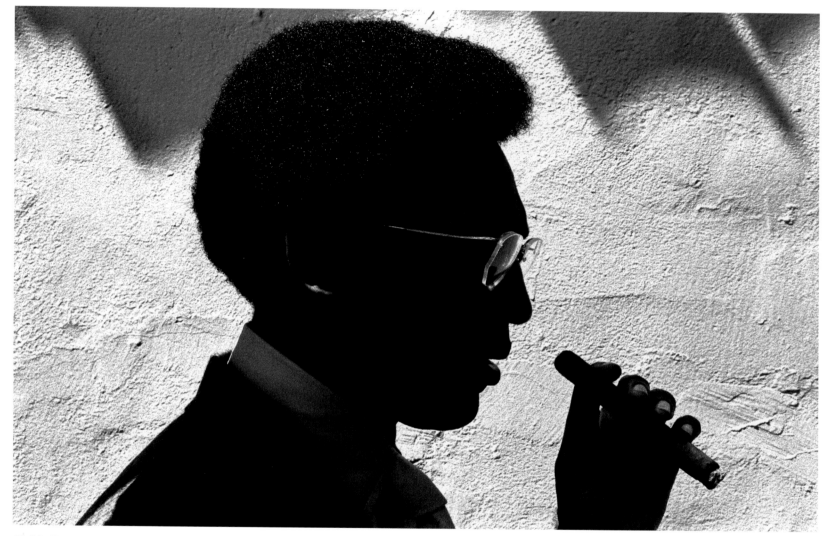

1969 Beverly Hills, California
In silhouette, Bill Cosby's facial expression disappears.

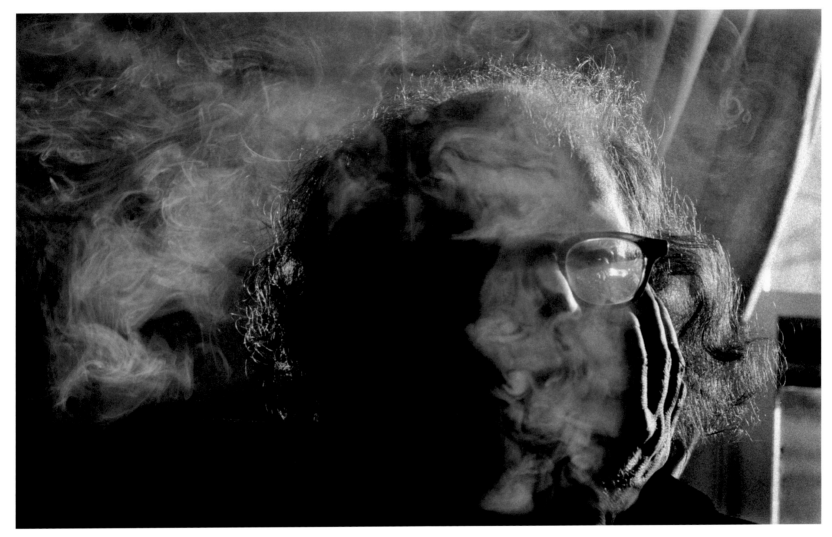

1966 Lawrence, Kansas
Poet Allen Ginsberg, in a cloud of tobacco smoke, talks on campus with undergraduates at the University of Kansas.

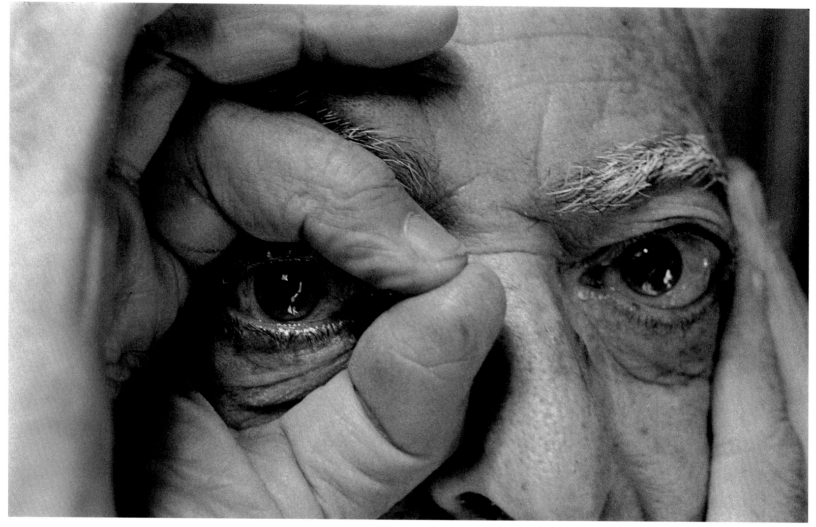

1981 Paris
The photographer Brassaï brings his fingers up to mimic mine as I twist my lens to focus on his eyes.

1976 Woolwich
My daughters, Jenna and Anna, flank their friends Corinna and Abigail Snyder.

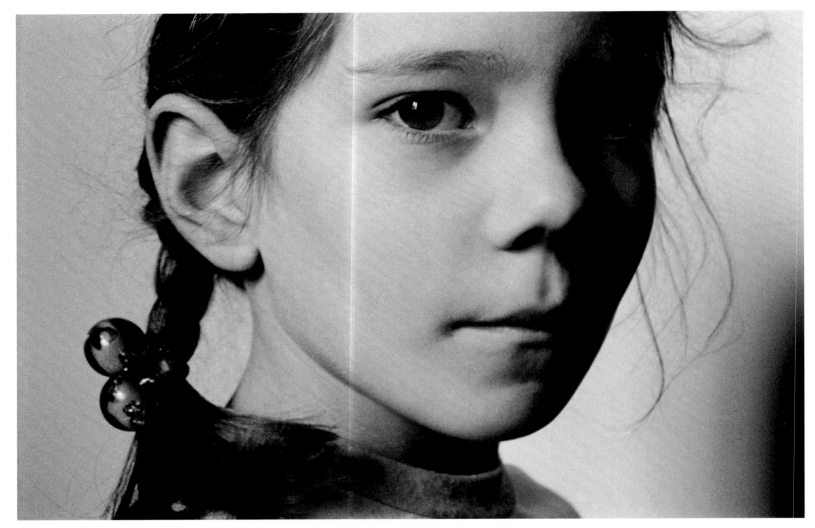

1975 New York City
My six-year-old daughter Anna faces the camera after school.

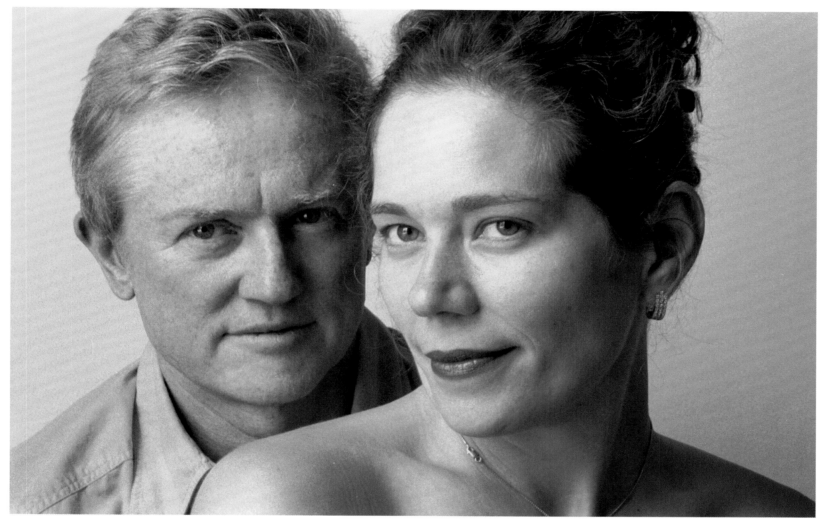

2005 New York City
Anna and Christian Wijnberg announce they will wed later this year.

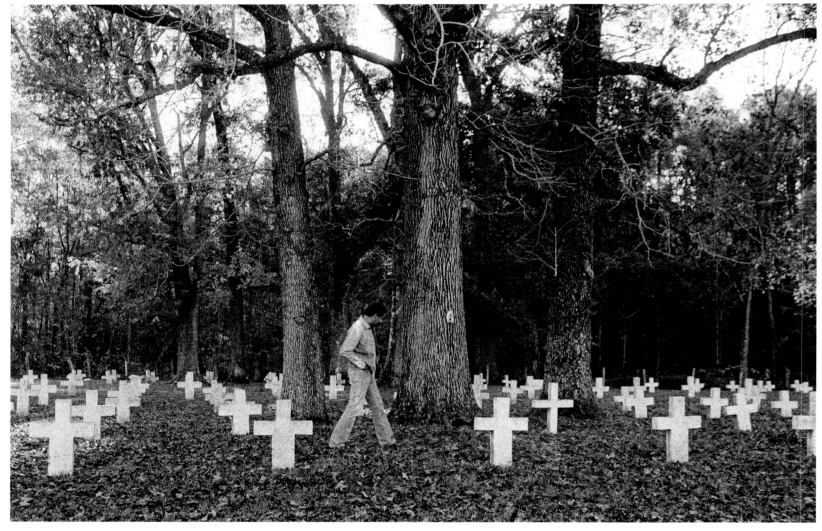

1992 Angola, Louisiana
Wilbert Rideau, fifty, walks through the graveyard for inmates at the Louisiana State Penitentiary.
He was sentenced to death for the 1961 murder of a bank teller during a robbery. Two
subsequent trials resulted in the same sentence, but in 1972 the Supreme Court temporarily
abolished the death penalty. In the two decades since, Rideau has become the editor of *The
Angolite*, the inmates' newspaper. He has turned it into a prize-winning publication.

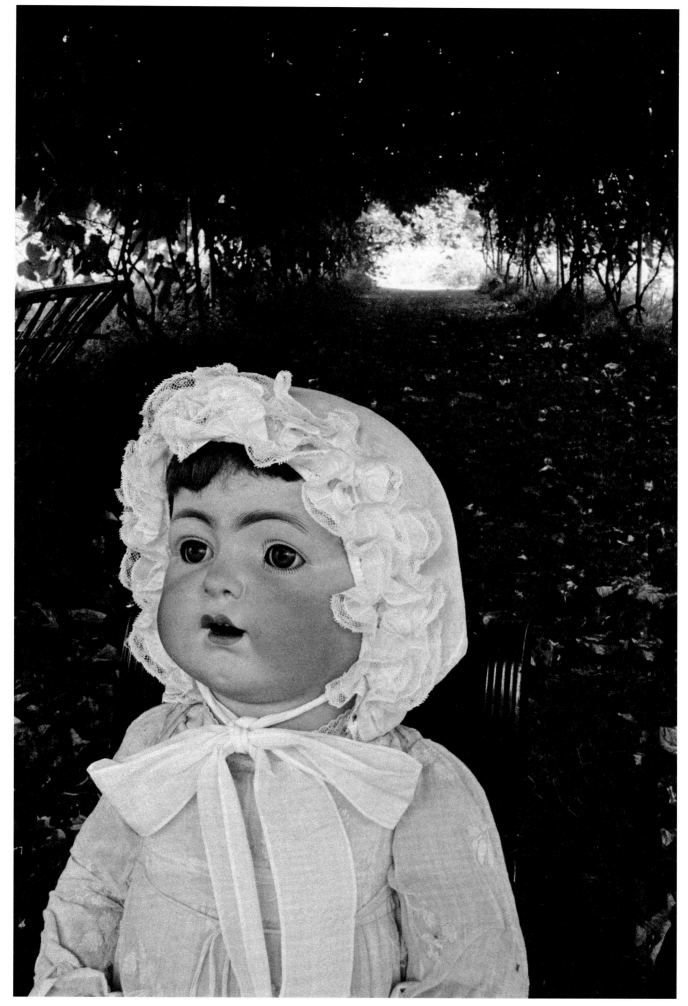

1972 Greenwich, Connecticut
A doll from the Pryor collection sits in an arbor next to the building where it is customarily on display.

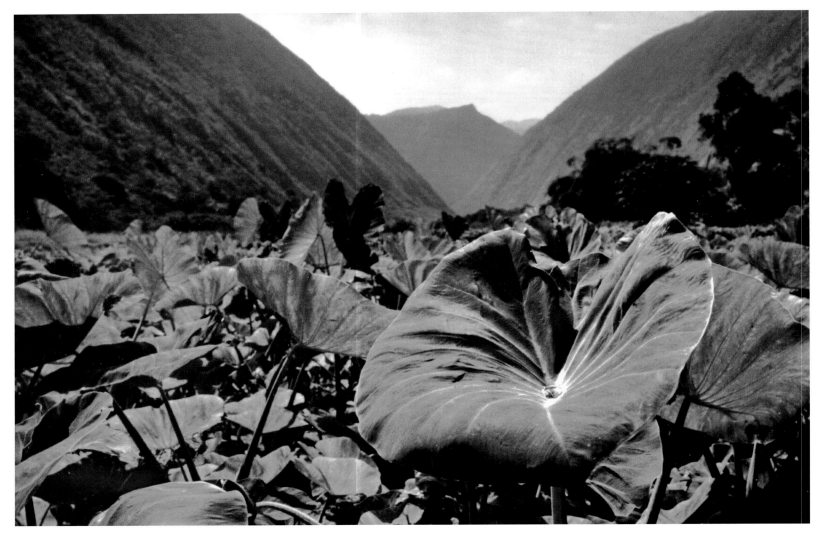

1983 Hawaii
Mrs. Duldulao's taro field is in the Waipio Valley on the Big Island of Hawaii.

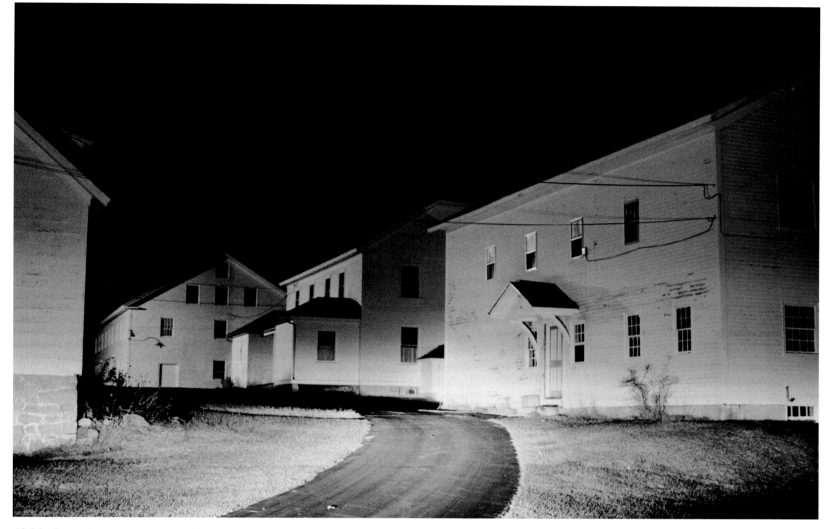

1966 Canterbury, New Hampshire
A car's headlights splash light on Shaker buildings.

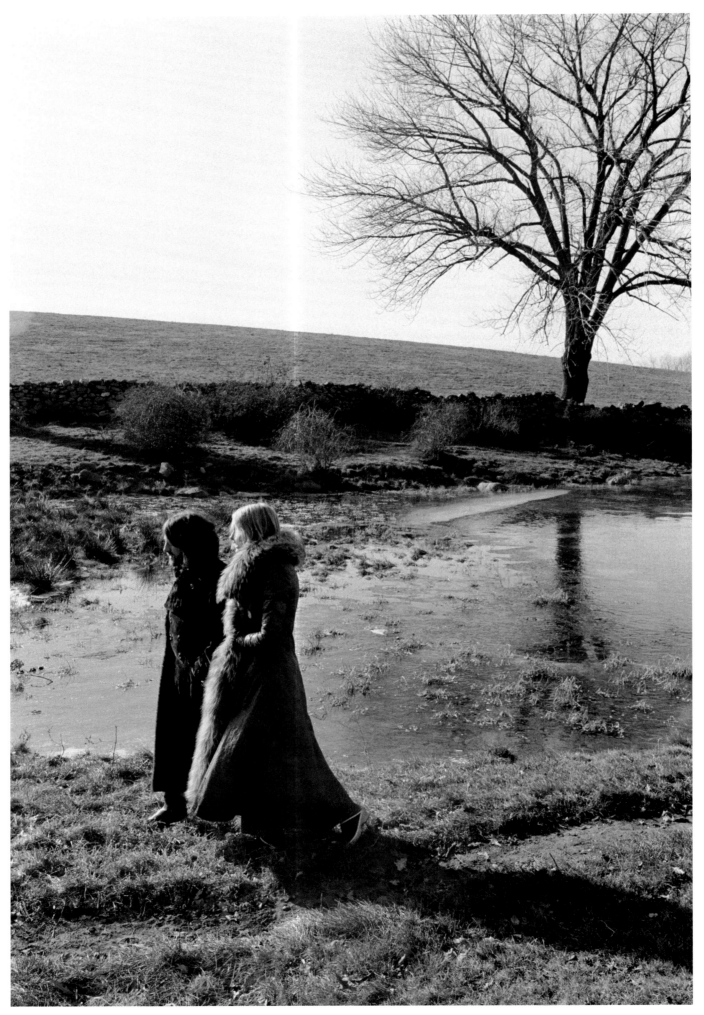

1972 Outside New York City
Nigel Davies dubbed his sixteen-year-old girlfriend "Twiggy" and changed his own name to
Justin de Villeneuve. He then managed Twiggy's career as a top-flight model in London and New York.

1972 Outside New York City
At twenty-two, Twiggy is quitting modeling for acting.
"You can't be a clothes hanger for your entire life," she says.

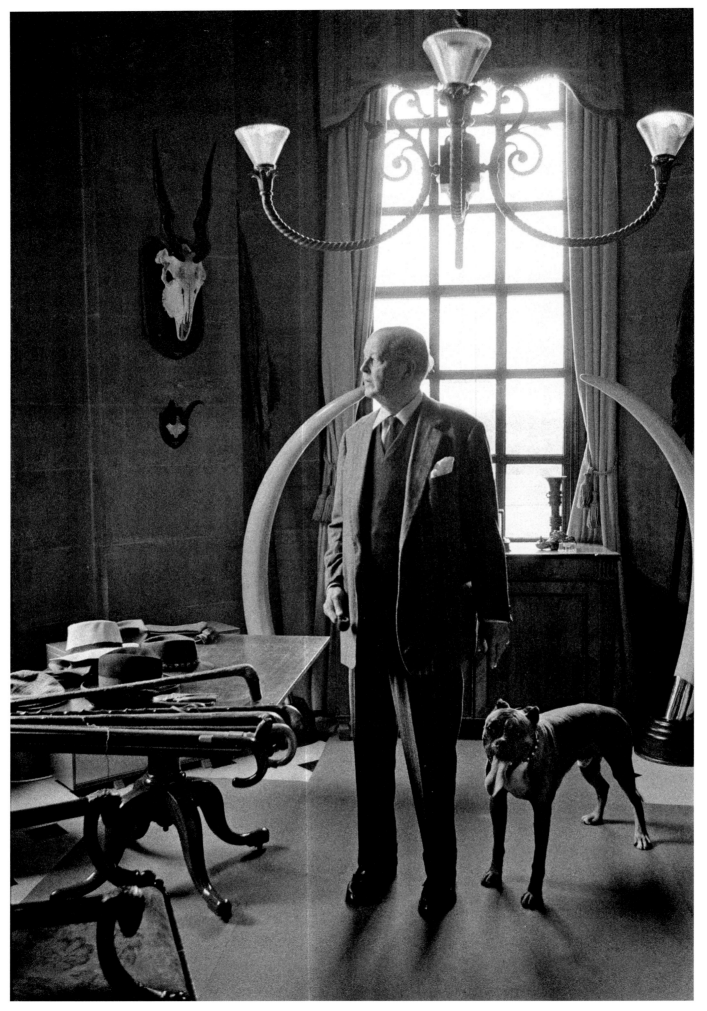

1968 Woodstock, England
John Albert William Spencer–Churchill, 10th Duke of Marlborough, commands a vestibule at Blenheim Palace.

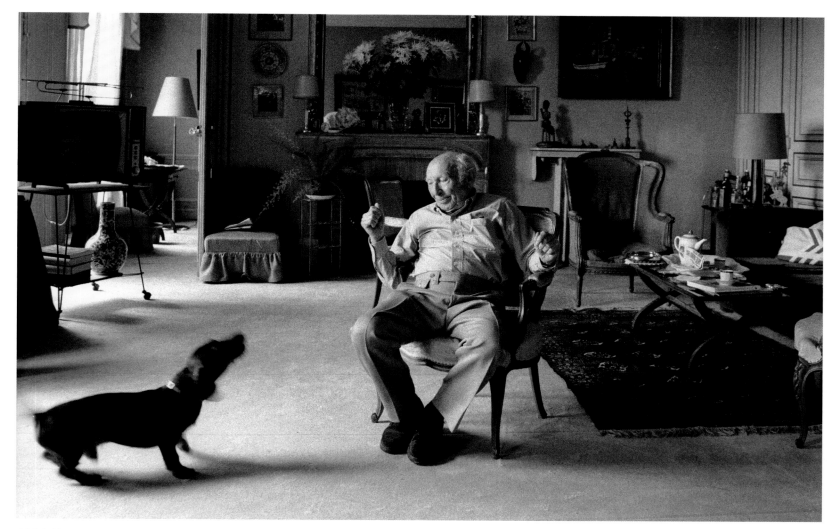

1984 Paris
Dmitri Kessel (who excels at capturing the calm of cathedrals in his camera)
is cornered by an excitable dachshund in his apartment.

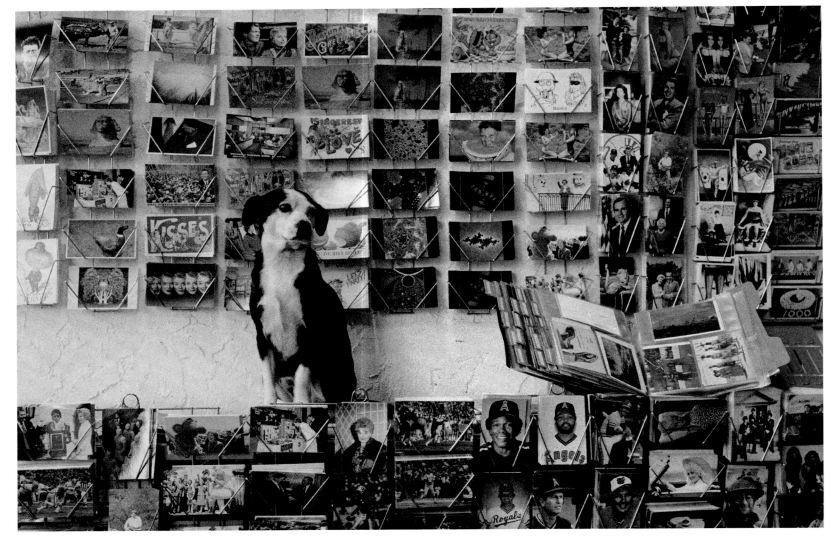

1990 San Francisco
Hobo is the companion of the proprietor of the Quantity Postcards Store.

1989 Paris
Roger Théron, editor-in-chief of the pictorial weekly *Paris Match*, takes the business
of editing photographs seriously. But his solemn face does not reflect the magazine's lively tone.

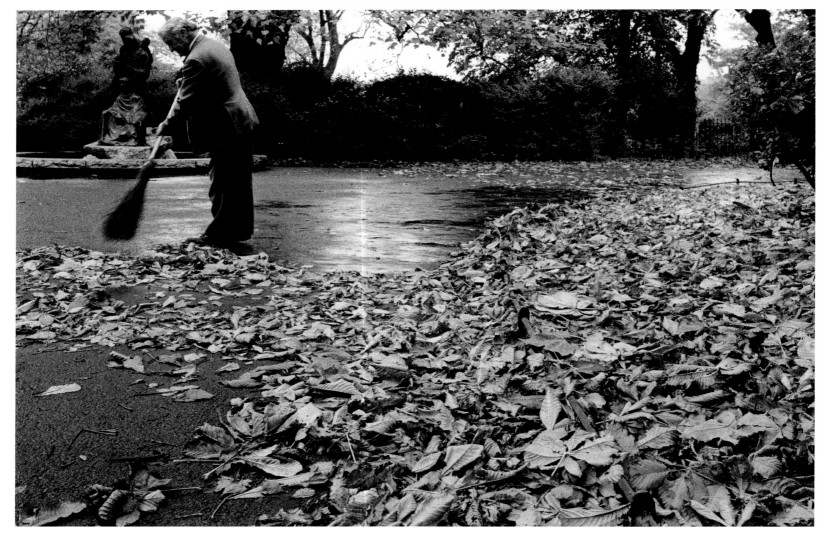

1987 Dublin
Groundskeeper John Byrna sweeps leaves off St. Stephen's Green.

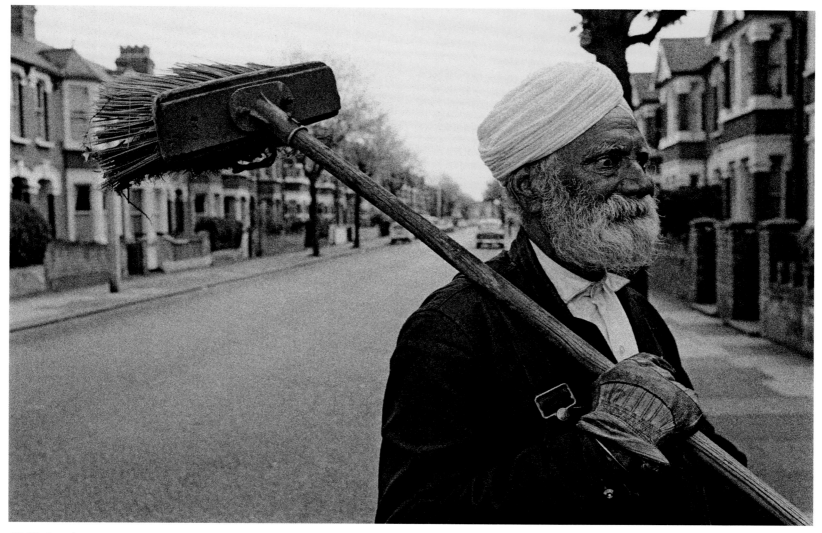

1968 London
A street sweeper snaps to attention when I ask if I might take his picture.

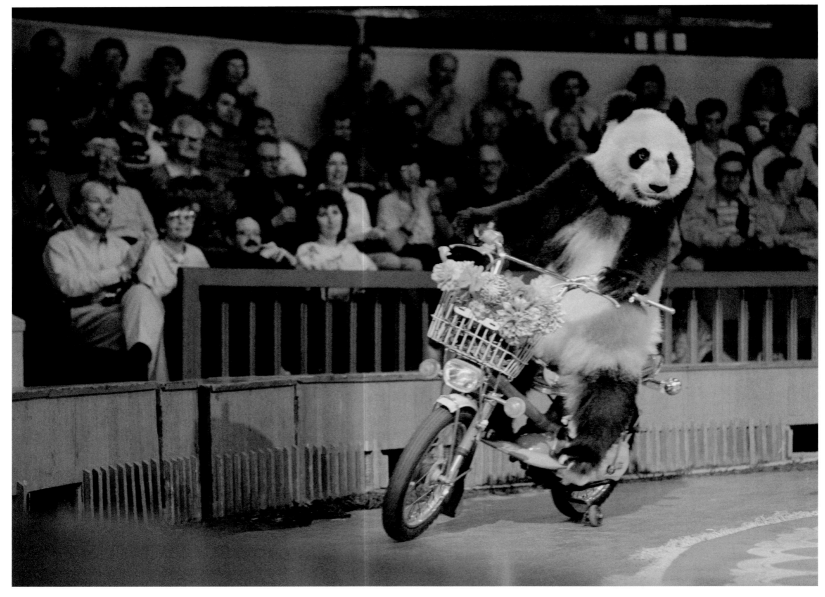

1987 Shanghai
A giant panda takes a spin on a motorbike.

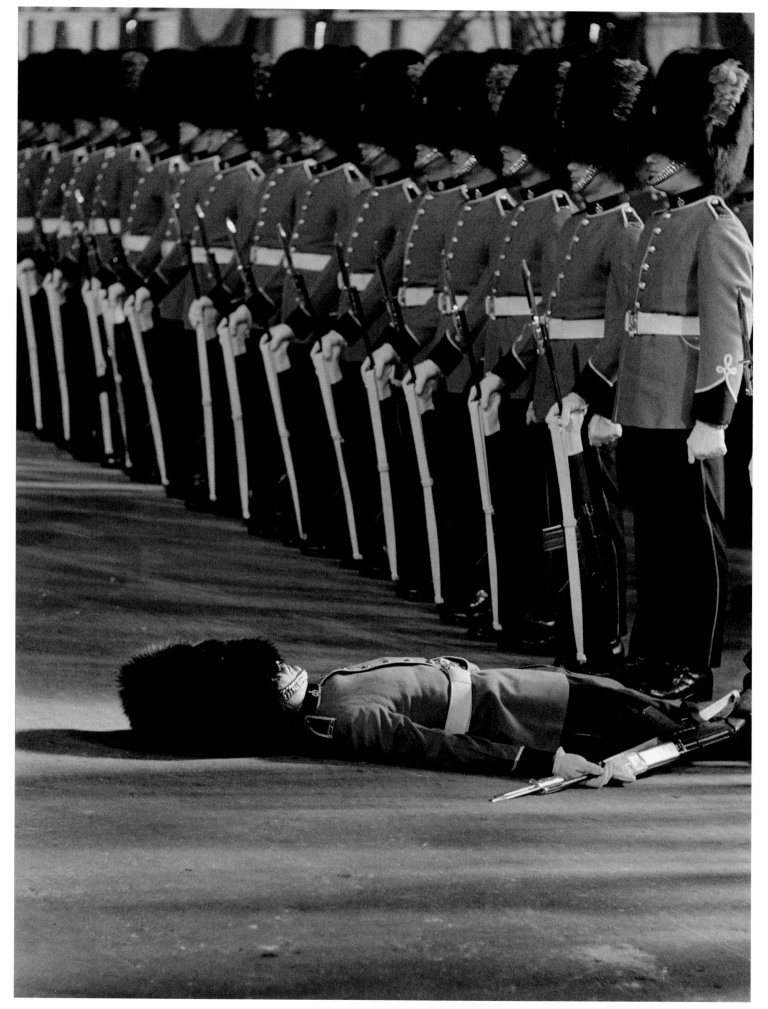

1964 Toronto, Ontario
A guardsman faints while standing at stiff attention awaiting Queen Elizabeth II to disembark from her yacht *Britannia*.

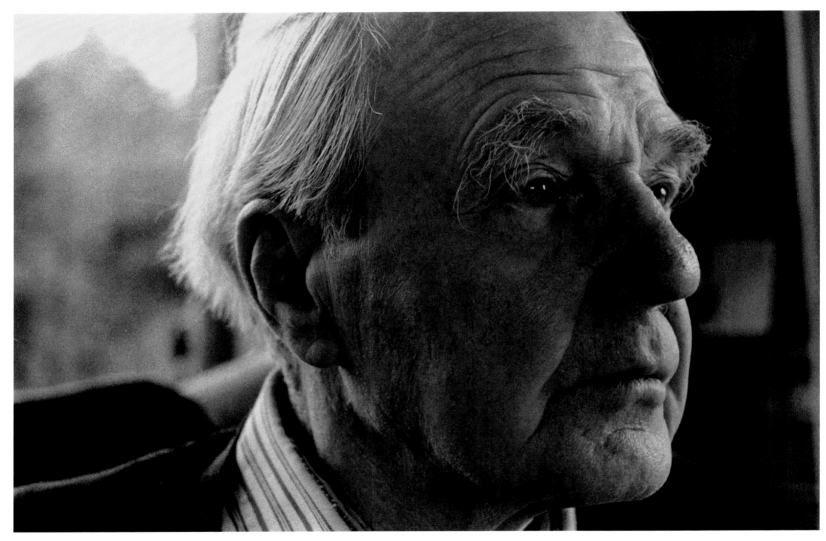

1983 Much Hadham, England
Sculptor Henry Moore, eighty-four, lives on a 55-acre estate in Hertfordshire, 30 miles north of London.

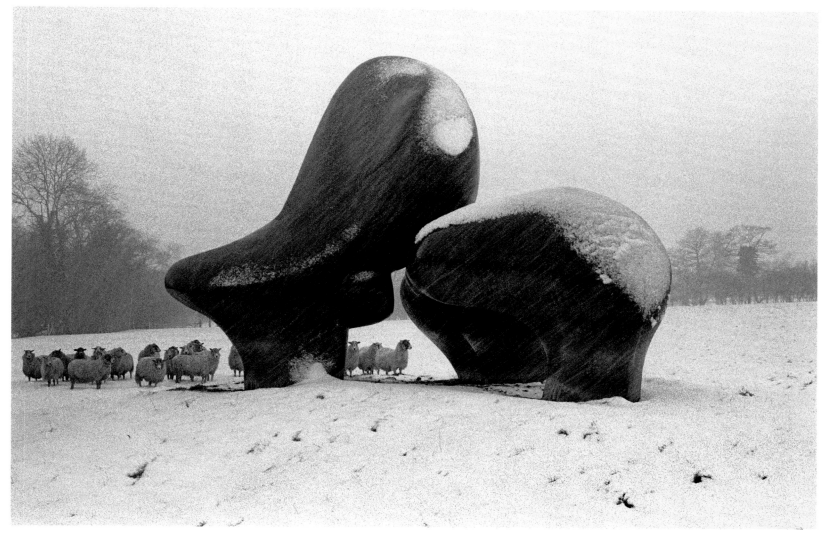

1983 Much Hadham
A neighbor's flock finds shelter beside *Sheep Piece* in the sculptor's meadow.
Moore believes sheep are a perfect scale for sculpture.

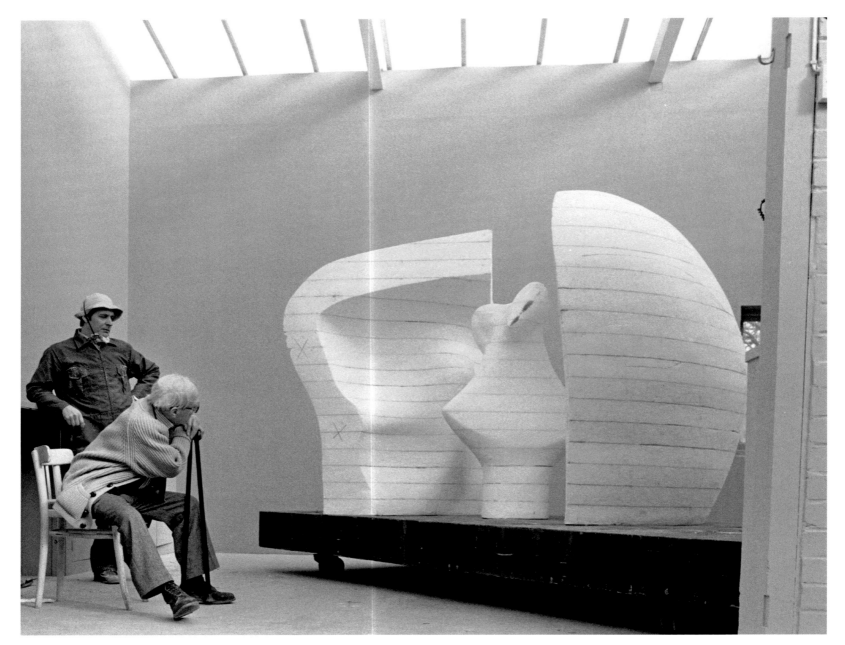

1983 Much Hadham
Consulting with assistant Malcolm Woodward, sculptor Henry Moore contemplates
the polystyrene maquette of a bronze commissioned for an office in Deerfield, Illinois.

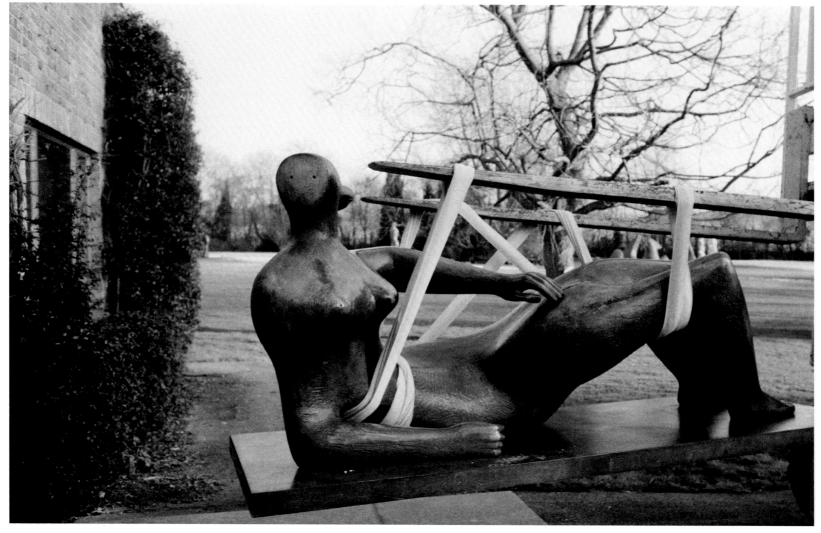

1983 Much Hadham
Moore believes that "we shall never get away from the fact that all sculpture is based on the human body."

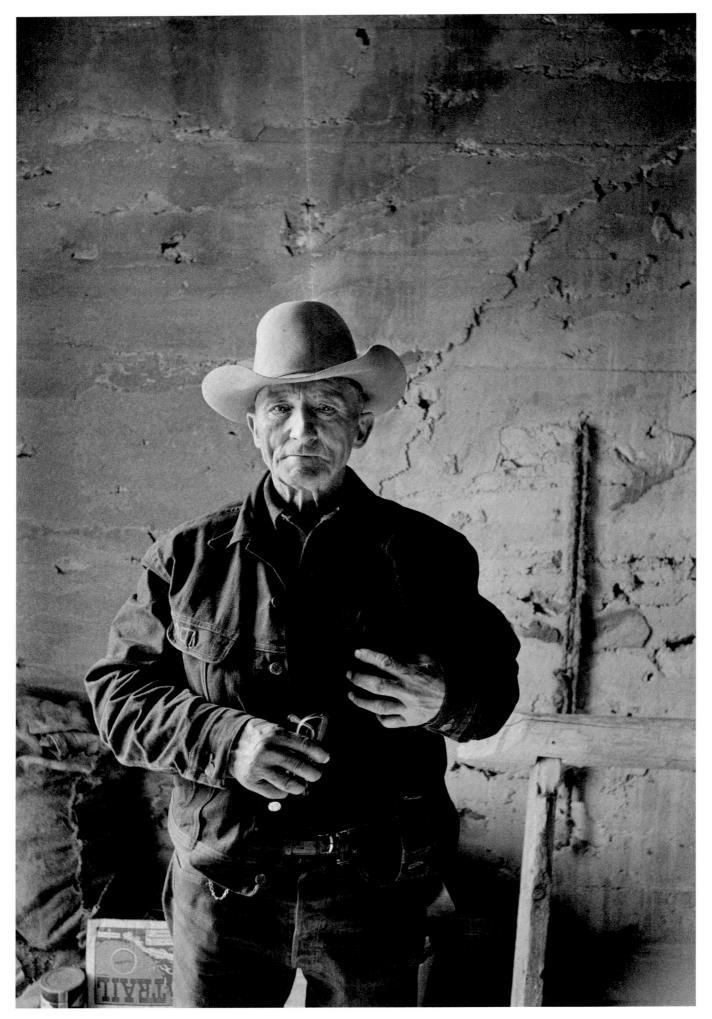

1970 Arizona
Raymond Holt, seventy, has been a cowboy since he was thirteen.
He winters on a line camp 50 miles northeast of Flagstaff.

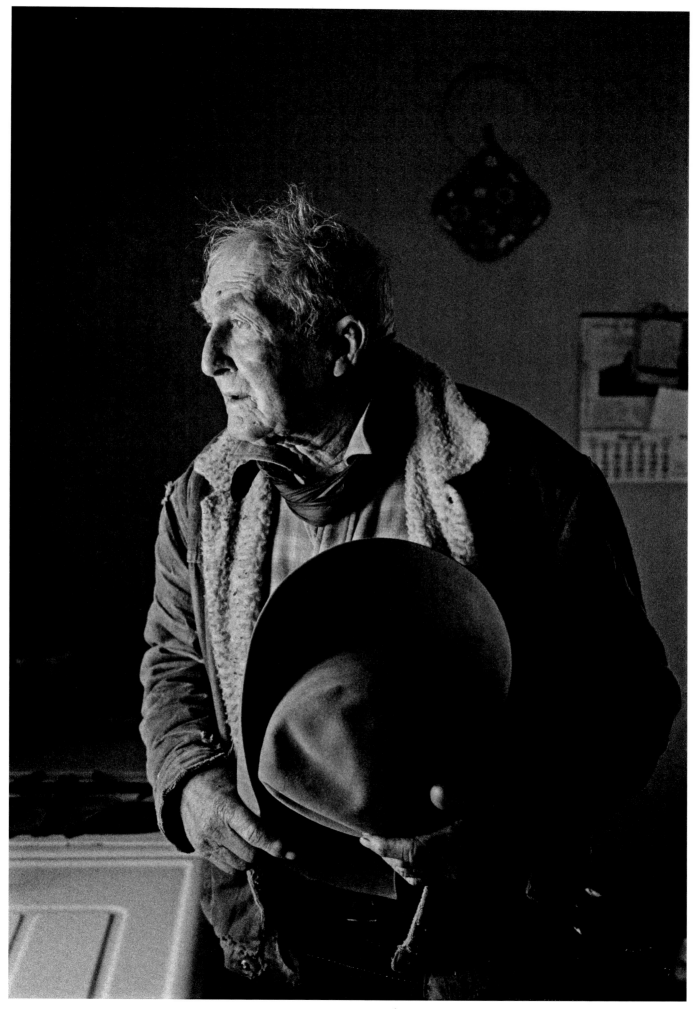

1970 New Mexico
When he was a cowhand sixty years ago, Fred Martin, eighty-five, was briefly (and unwillingly, he says) a lieutenant
in Pancho Villa's rebel army in Mexico. He now owns a ranch on the San Augustin Plain in New Mexico.

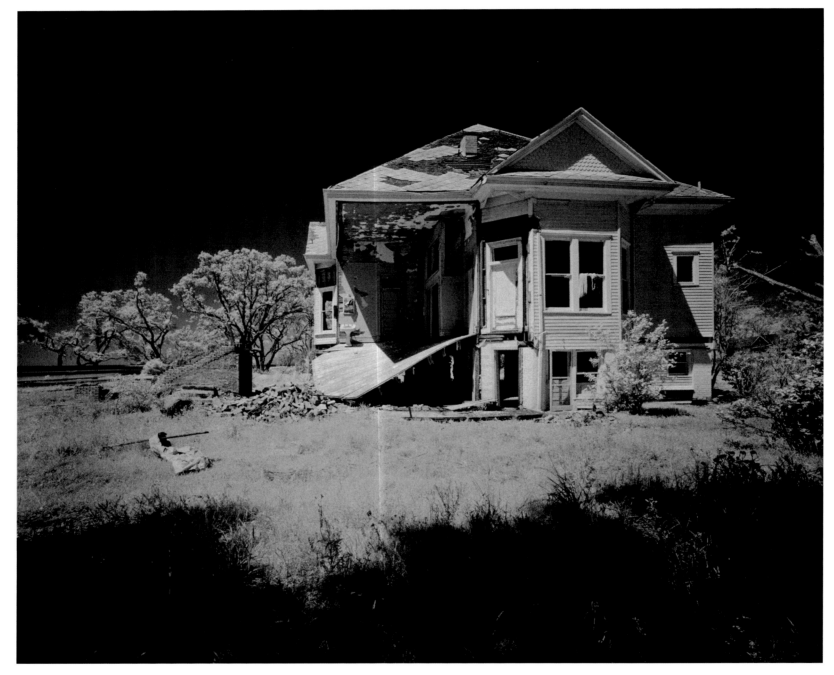

1970 Gulfport, Mississippi
Stripped by Hurricane Camille's 190-mile-an-hour winds
six months earlier and looters since, a 1906 home is ready to be bulldozed away.

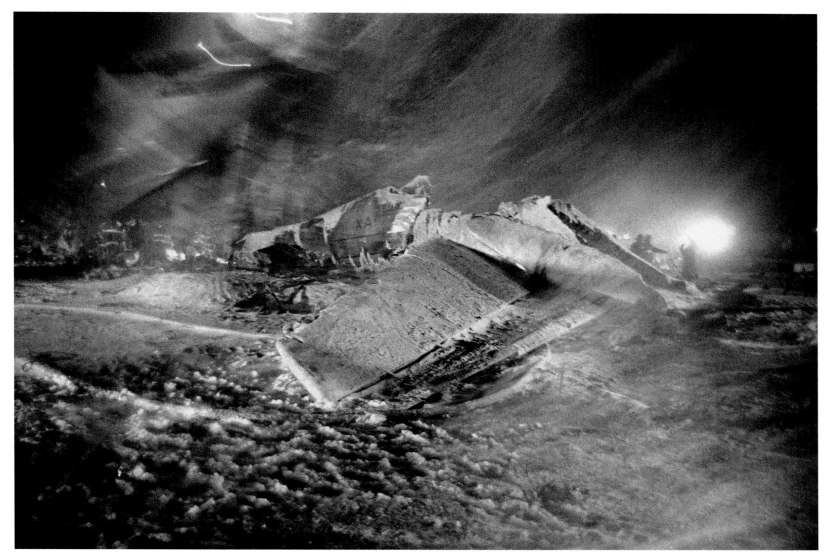

1961 New York City
An Aeronaves de Mexico jet aborts its takeoff in New York City.
Four crew members die; 106 crew and passengers survive.

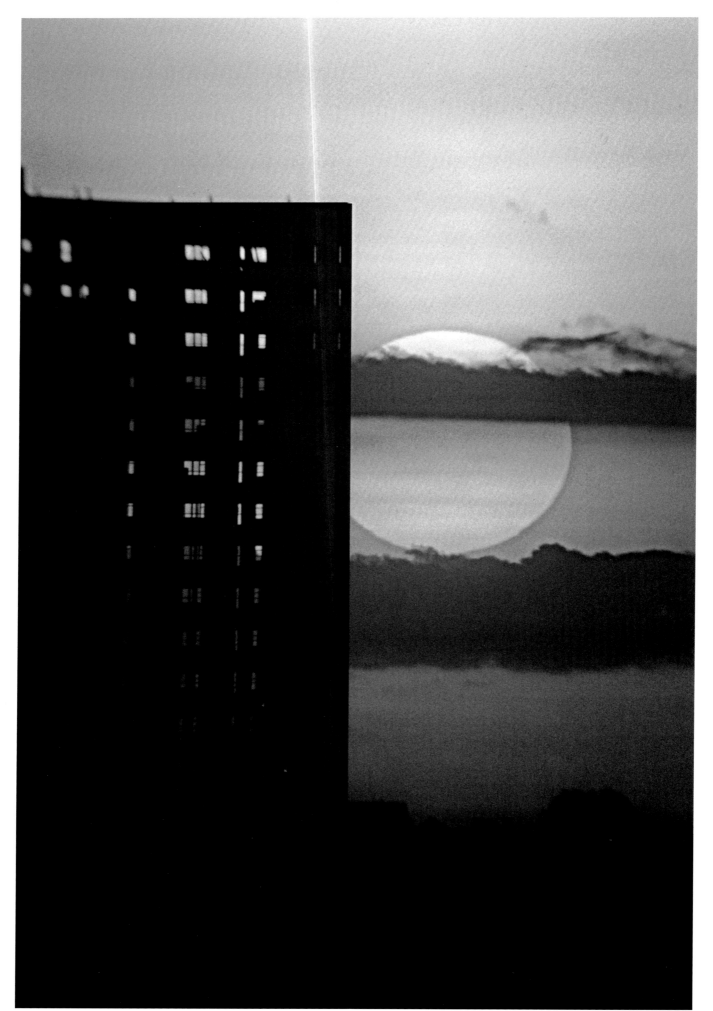

1964 New Jersey
Through a toy telescope, a building across the Hudson River from my Manhattan apartment
becomes a marker on a sundial of the season. It is a quarter-past June (above); then it's half-past July (opposite).

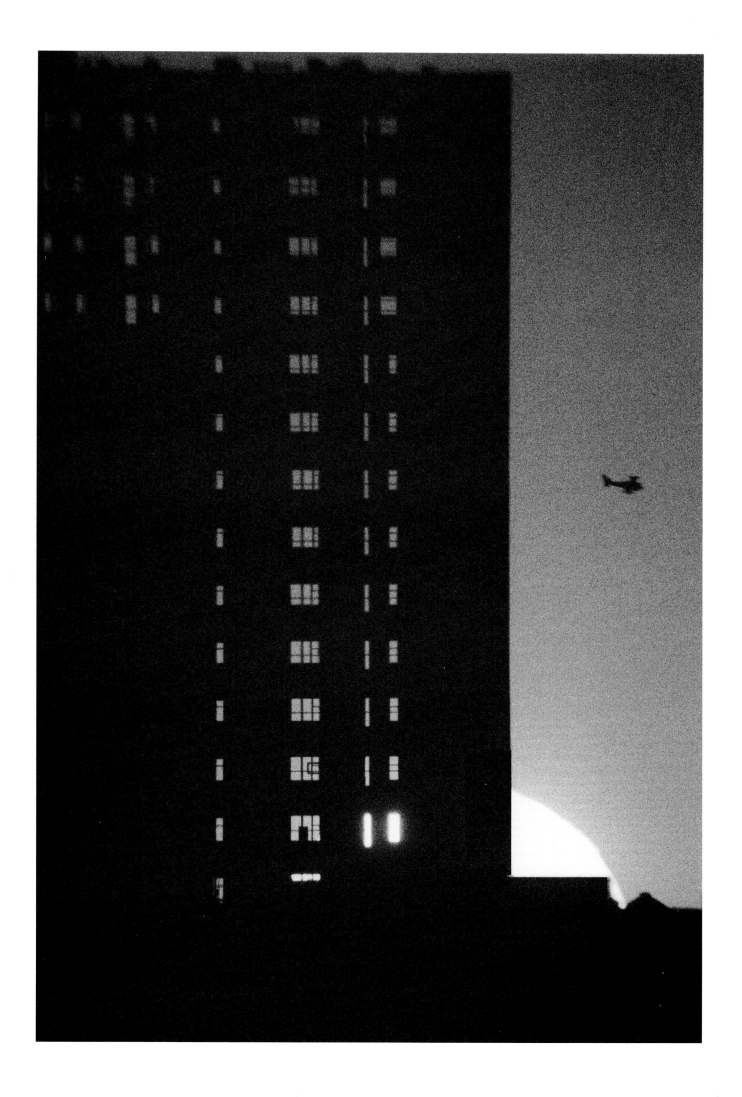

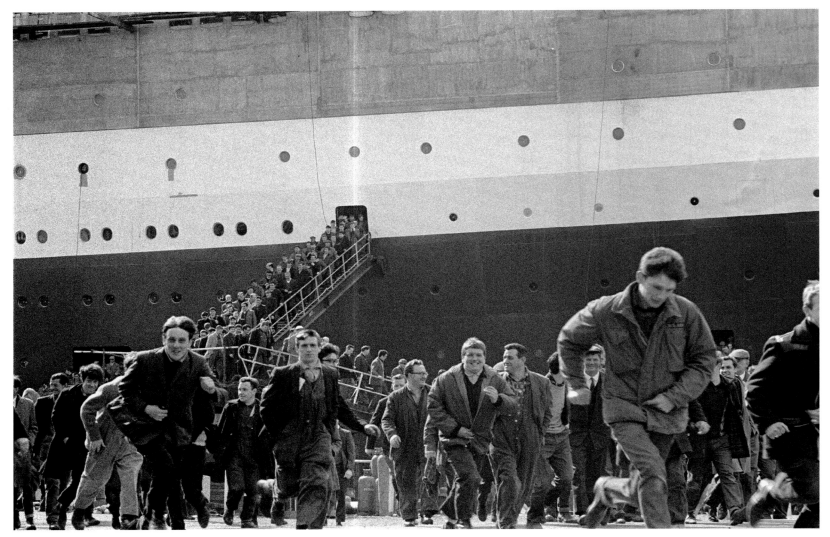

1968 Glasgow
Builders of the ocean liner *Queen Elizabeth II* quit work for the day.

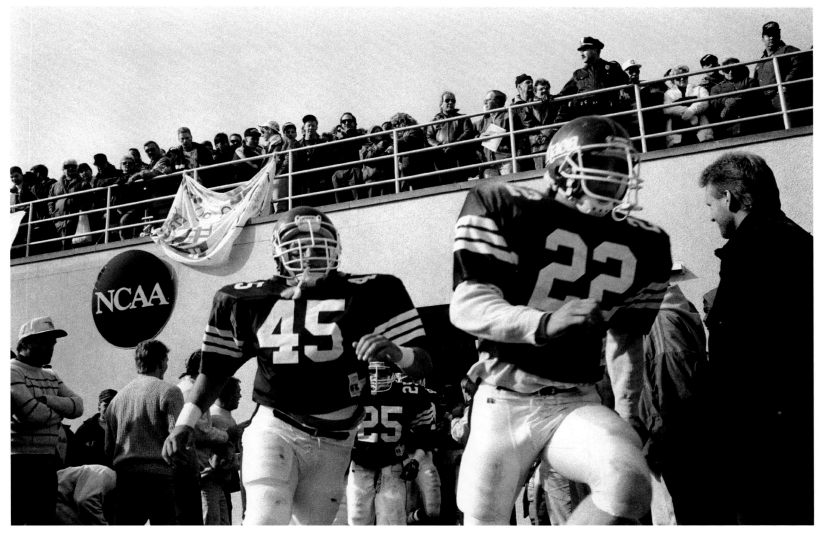

1989 Ithaca, New York
The varsity comes on the field.

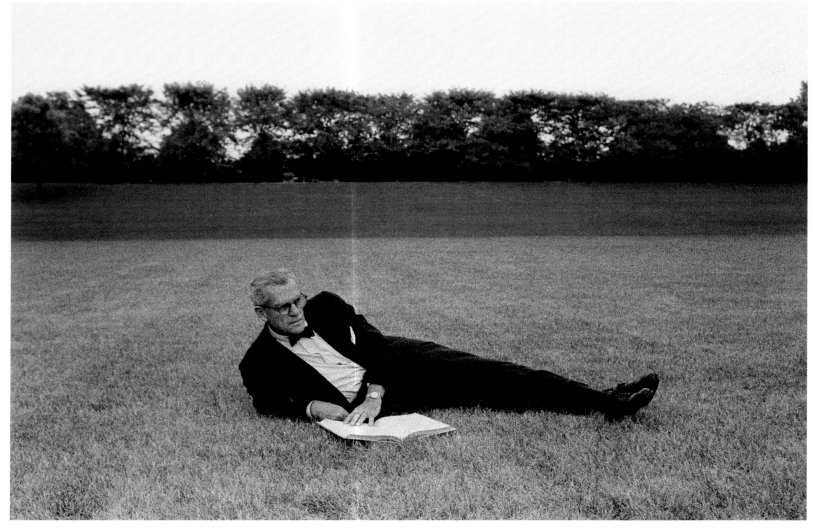

1967 Columbus, Indiana
Eero Saarinen designed industrialist J. Irwin Miller's home, and Dan Kiley planned the landscape that
hides it from view behind two rows of honey locust trees at the far edge of the meadow where Miller stretches out.

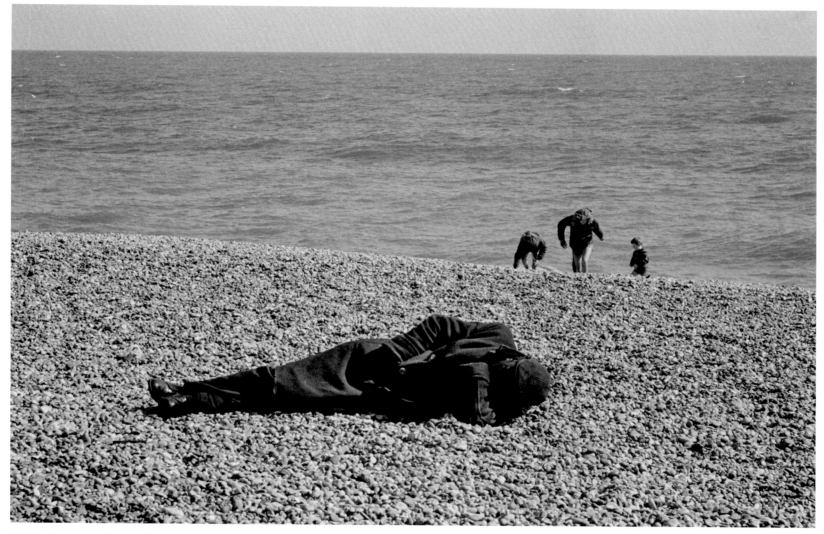

1968 Brighton, England
A determined dozer plies the beach in May.

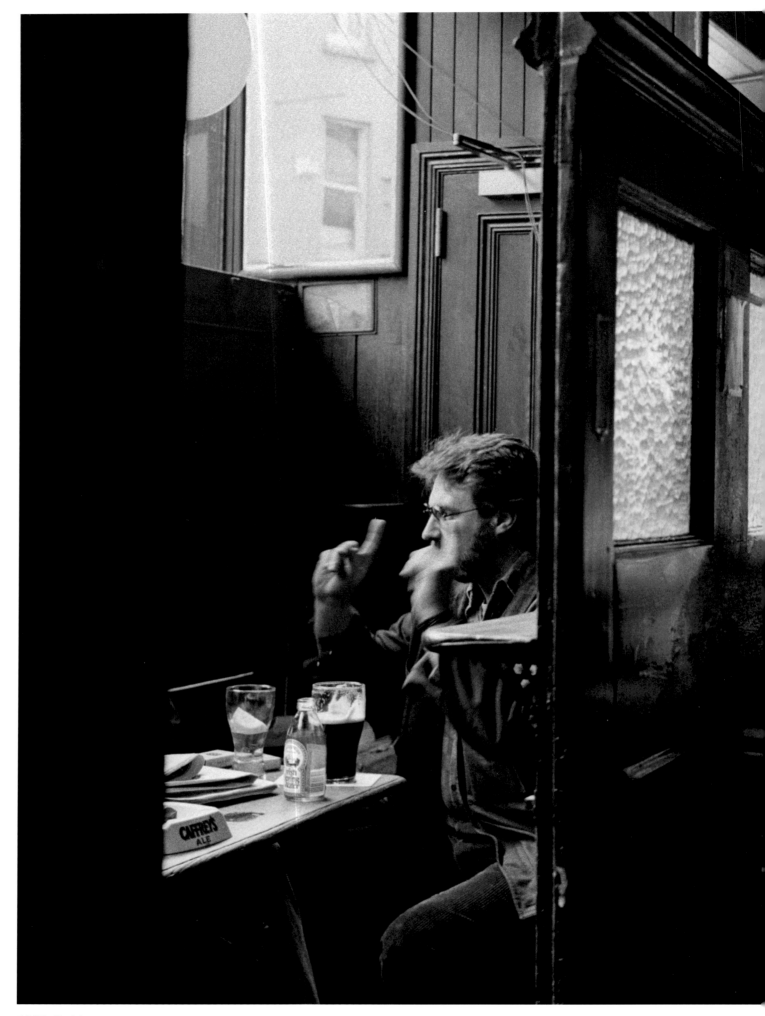

1987 Dublin
Tom Nesbitt tends his bar.

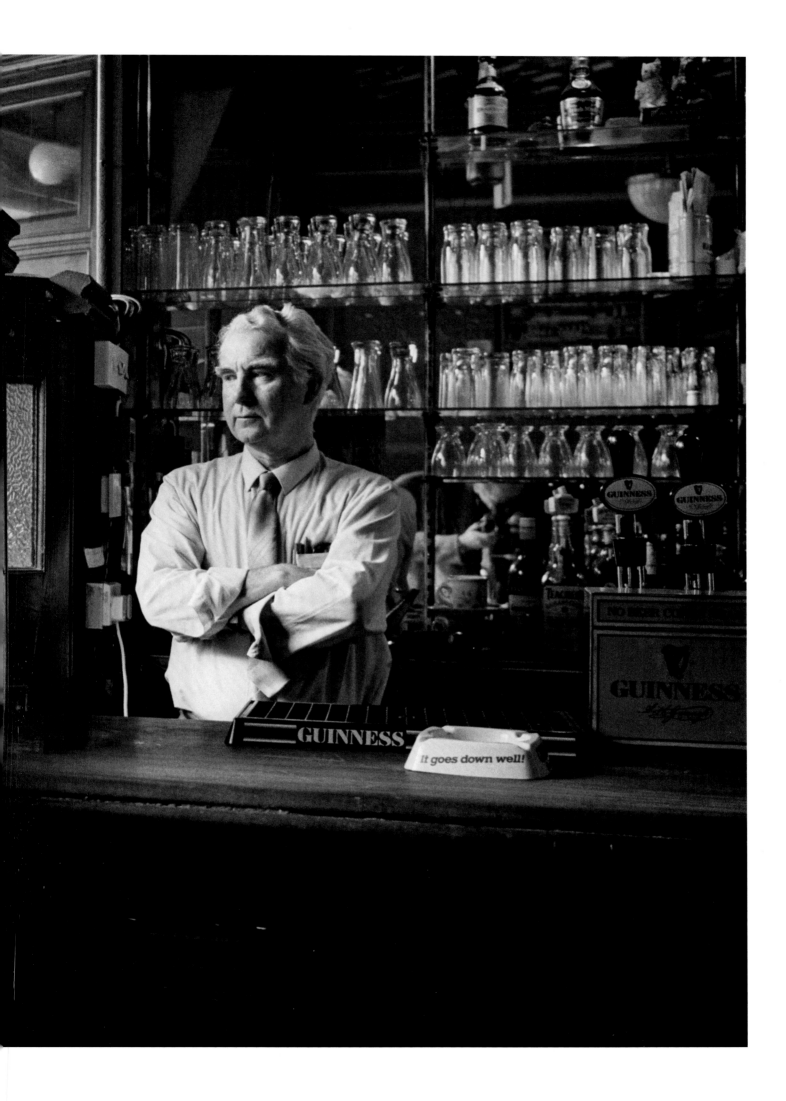

INDEX